Where Love Is

ARTWORK BY ROBERT DUNCAN

Where Love Is

ARTWORK BY ROBERT DUNCAN

EAGLE
GATE

Visit us at www.deseretbook.com

Library of Congress Cataloging-in-Publication Data

Duncan, Robert, 1952–
 Where love is / Robert Duncan.
 p. cm.
 Includes bibliographical references.
 ISBN 1-57008-859-4 (alk. paper)
 1. Duncan, Robert, 1952– 2. Family in art. I. Title.
ND237 .D769 A4 2002
759.13—dc21 2002009755

Printed in the United States of America 42316-6994
Inland Press, Menomonee Falls, WI

 10 9 8 7 6 5 4 3 2 1

To Linda, who made it all possible. To my children, Joshua, Mandy, Christian, Brianne, Braden, and Cullen. And to our little grandson, Ethan. This sweet family has been my constant joy and my greatest inspiration, for which I will forever be grateful.

I am also grateful to Jana Erickson and Deseret Book for the creation of this book. I am proud of it because I feel that it successfully puts across some of what is important to me.

Life is full of trials for all men and women, but I believe we have been given gifts that can make our trials bearable and our days full of joy, if we make the effort to search out those gifts and build our lives around them. The greatest gift is love—love given and love received. One of my heroes, artist Carl Larsson, said, "Love life, love thy neighbor, love animals, love the garden and the flowers! Love! Love! That is the solution to the puzzle of life."

Good Times

The greatest legacy we can leave our children is happy memories: those precious moments so much like pebbles on the beach that are plucked from the white sand and placed in tiny boxes that lie undisturbed on tall shelves until one day they spill out and time repeats itself, with joy and sweet sadness, in the child now an adult. . . . Memories. Love's best preservative.

—OG MANDINO

Nature is God's Workshop.

—Max Lucado

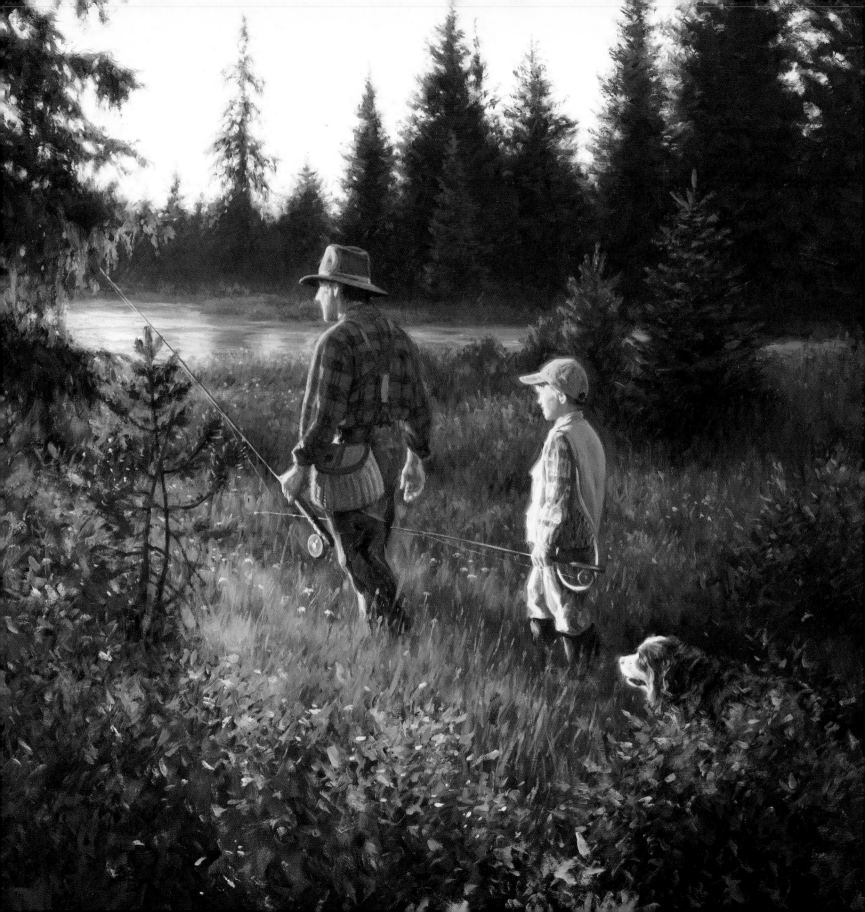

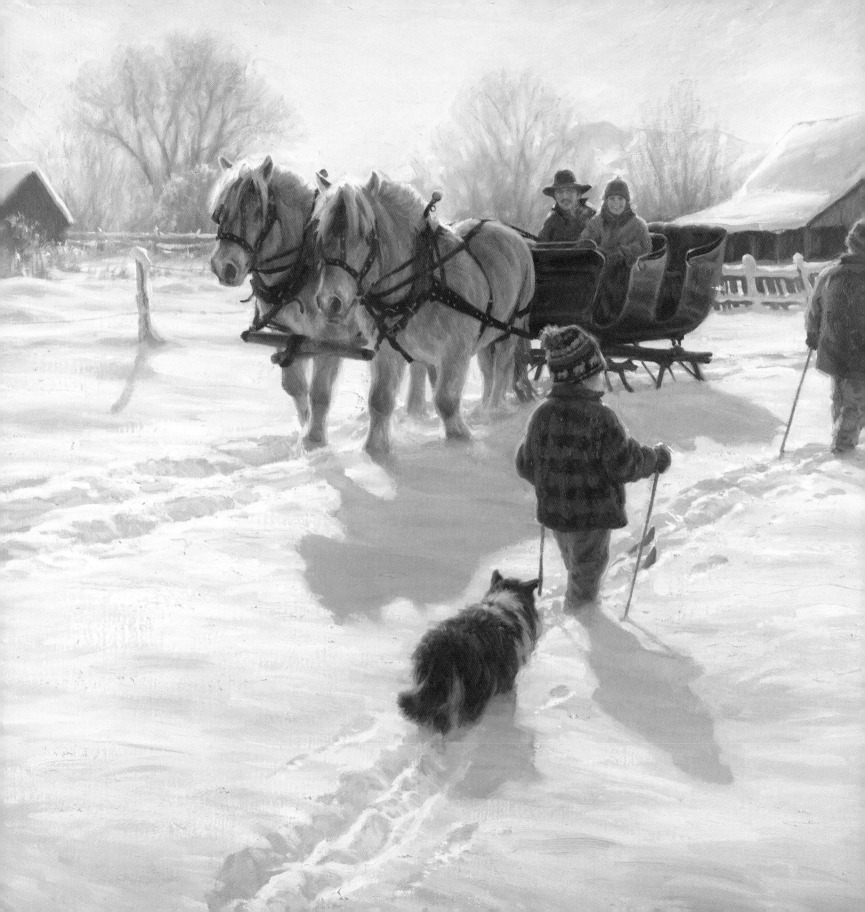

A Grand Day

N o one is guaranteed happiness. Life just gives each person time and space. It's up to us to fill it with joy.

—Anonymous

Life is a splendid gift—
there is nothing small about it.

—Florence Nightingale

Free as a Bird

If the day and the night are such that you greet them with joy, and life emits a fragrance like flowers and sweet-scented herbs, is more elastic, more starry, more immortal—that is your success. . . . The true harvest of my daily life is somewhat as intangible and indescribable as the tints of morning or evening. It is a little star-dust caught, a segment of the rainbow which I have clutched.

—HENRY DAVID THOREAU

The
Magic Hour

T
here is an enduring tenderness
in the love of a mother.

—WASHINGTON IRVING

Children are the hands by

which we take hold of heaven.

—Henry Ward Beecher

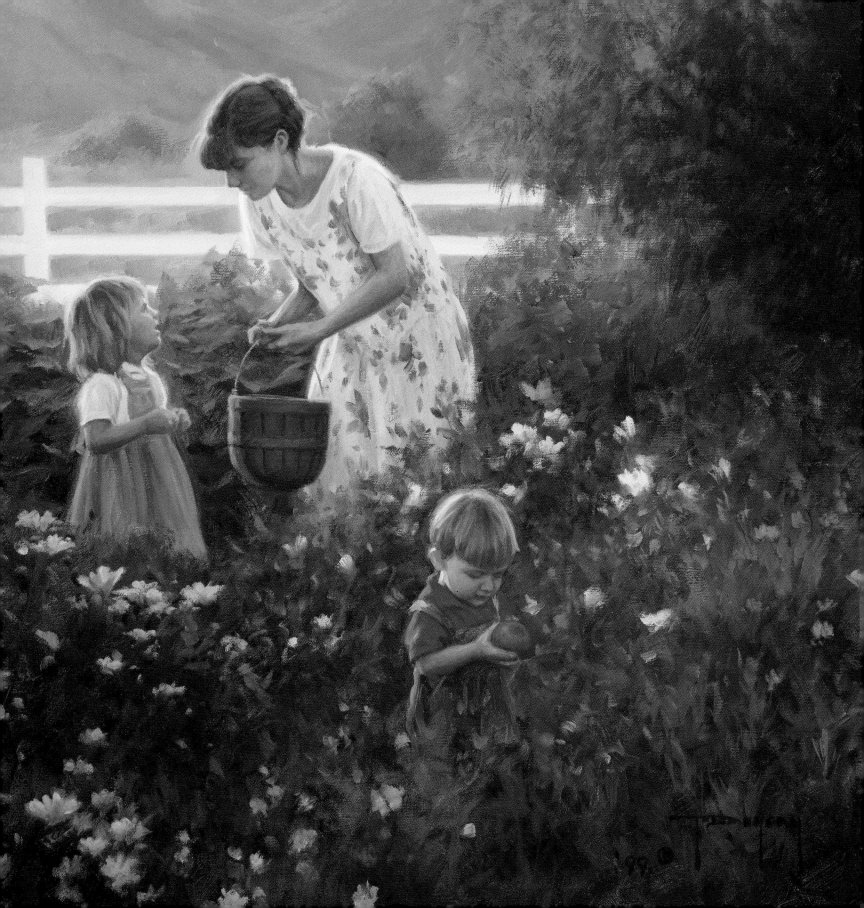

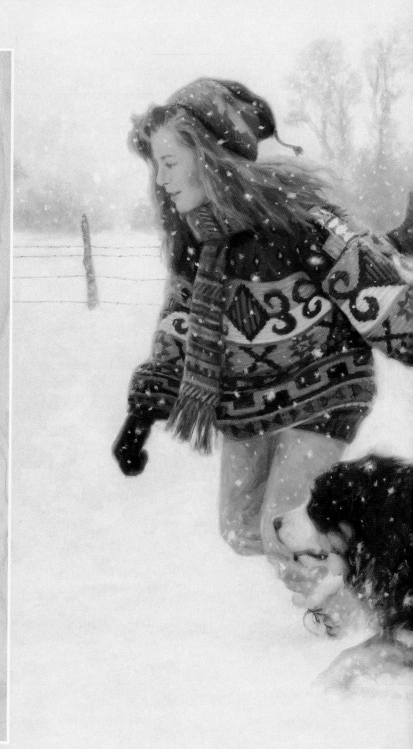

Celebration

When trials cool your ardor for life, snuggle into the warm companionship of friends and family. Be open to the humor that can bring light to the darkest night. When tumbleweeds blow about your winter evening, invent happy memories. Choose joy over sorrow. Be enticed toward happiness.

—MILDRED BARTHEL

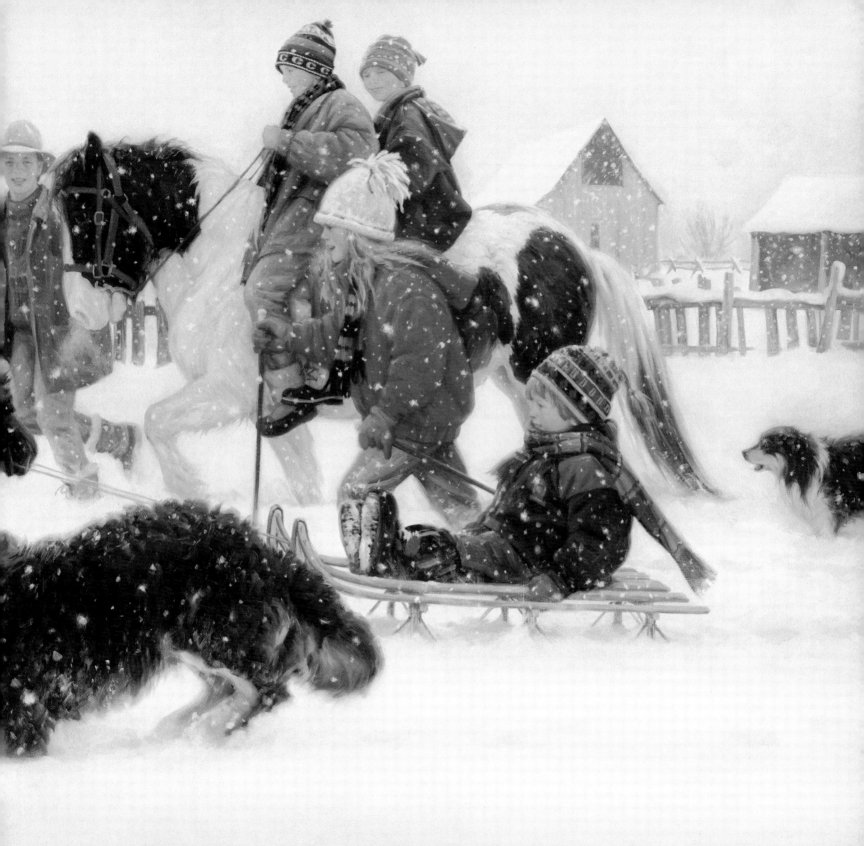

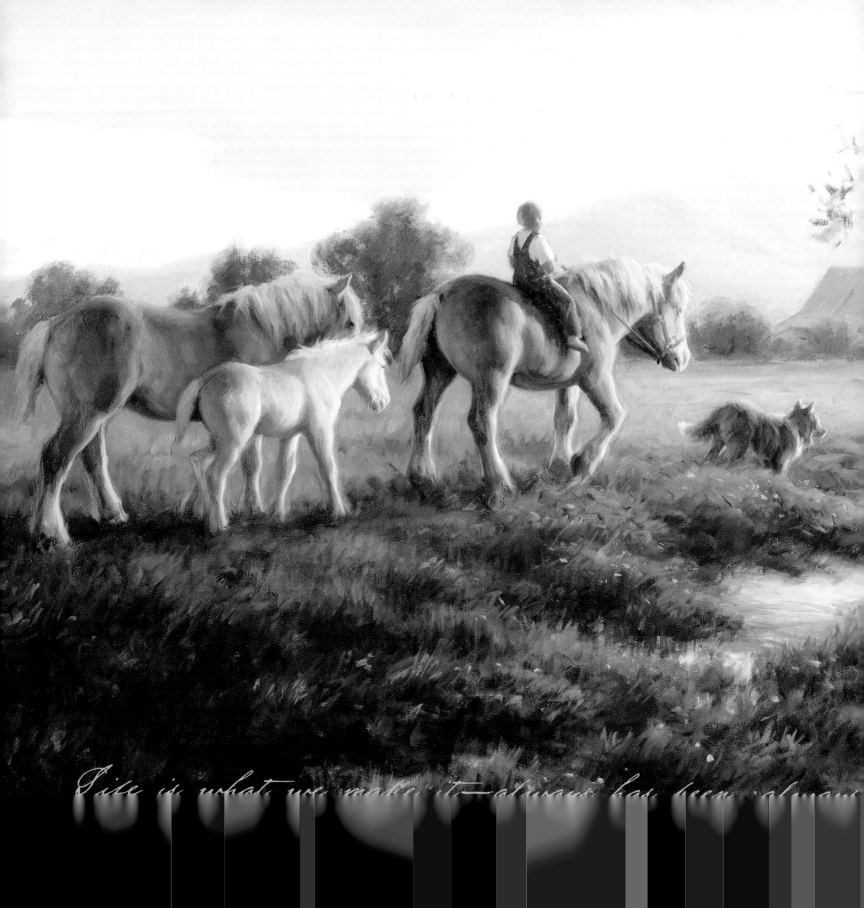

will be.

Almost Home

I breathe deeply the brisk air and release it slowly to watch the white clouds form and disappear. Goose pimples pebble my arms and legs. I shiver. Somewhere a rooster crows and bells clang from the sheep corrals. . . . The morning whispers peace to my homecoming.

—CHERYL ANN TOLINO

At the Mill Pond

Four ducks on a pond,

A grass bank beyond,

A blue sky of spring,

White clouds on the wing;

What a little thing

To remember for years—

To remember with tears!

—WILLIAM ALLINGTON

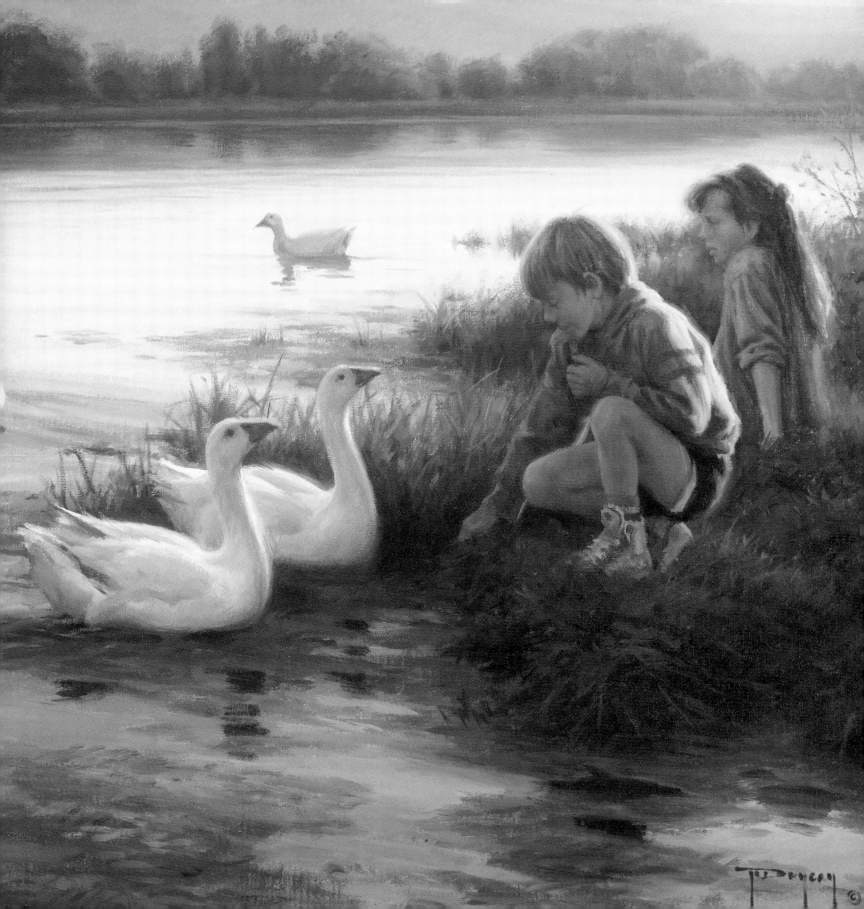

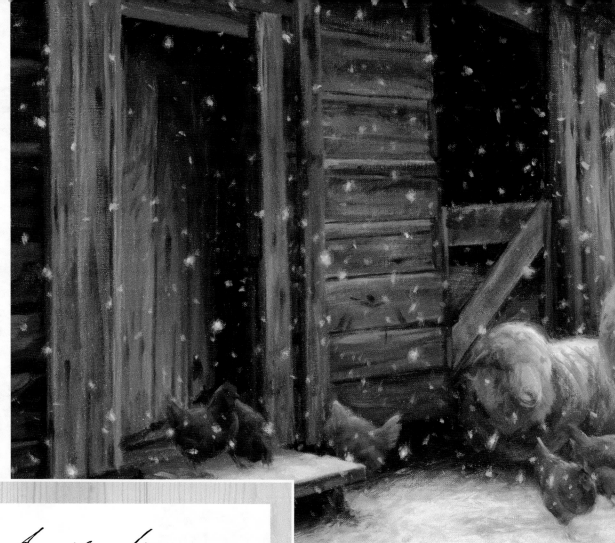

An April Storm

Announced by all the trumpets of the sky,

Arrives the snow, and, driving o'er the fields,

Seems nowhere to alight: the whited air

Hides hills and woods, the river, and the heaven,

And veils the farmhouse at the garden's end.

—RALPH WALDO EMERSON

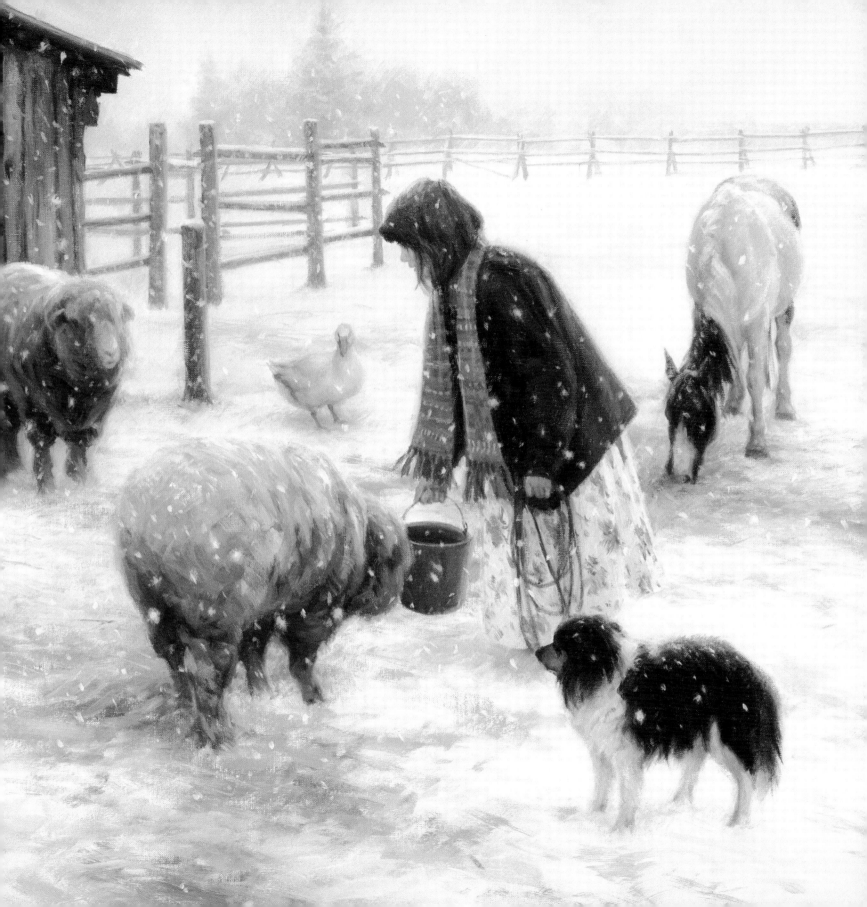

The Last Leaves

This shaggy day

With the lawn lying gold and tangled

I should have cut it

With the leaves falling

Everywhere like discarded gloves

I should have raked them

With chrysanthemums bowing over the walk

I should have clipped them

I was never one for cutting

Raking

Clipping

Hurrying away a season

Let the lawn thicken into carpet

The leaves crumble into spice

Let the flowers soften

Scattering pale petals at the bidding

Of the wind

Beauty must have time

Seek its own ending

Write its own poem

—SHIRLEY HOWARD

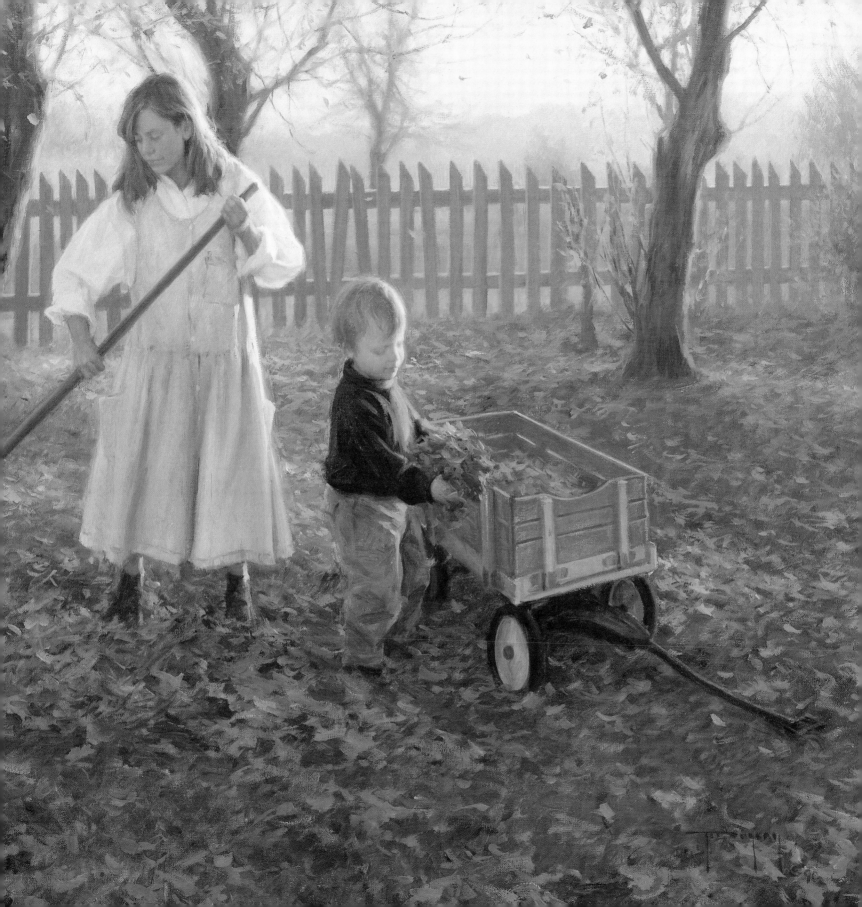

A Bit of Heaven

There is something greater and purer than what the mouth utters. Silence illuminates our souls, whispers to our hearts, and brings them together. Silence separates us from ourselves, makes us sail the firmament of spirit, and brings us closer to Heaven.

—KAHLIL GIBRAN

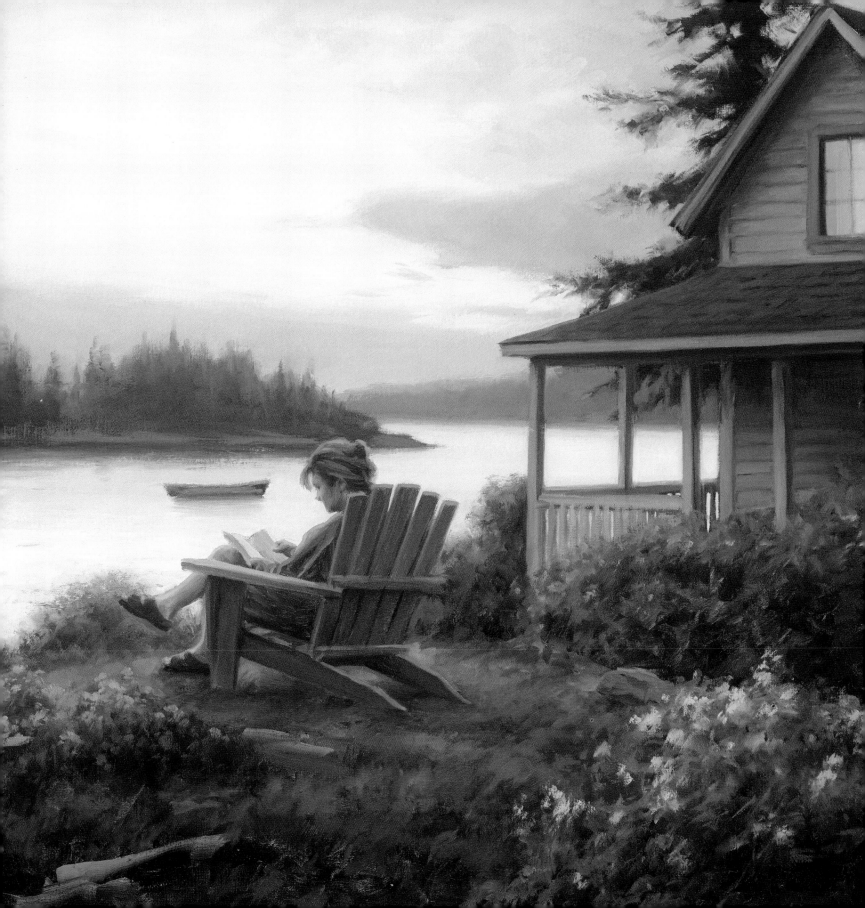

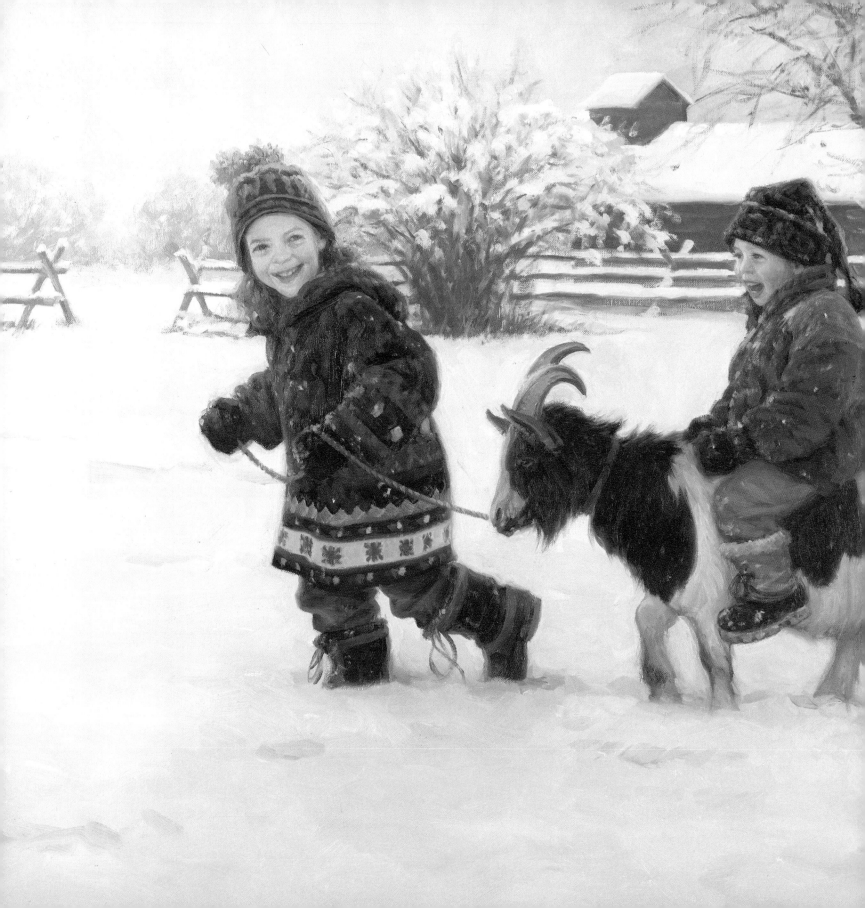

Our Friend Murphy

We fill the hands and nurseries of our children with all manner of dolls, drums, and horses, withdrawing their eyes from the plain face and . . . nature, the sun and moon, the animals, the water and the stones which should be their toys.

—RALPH WALDO EMERSON

Companions

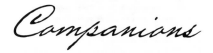

Hear our prayer, Lord, for all animals,

May they be well-fed and well-trained and happy;

Protect them from hunger and fear and suffering;

And, we pray, protect especially, dear Lord,

The little cat who is the companion of our home,

Keep her safe as she goes abroad,

And bring her back to comfort us.

—AN OLD RUSSIAN PRAYER

We cannot live only for ourselves.

—Herman Melville

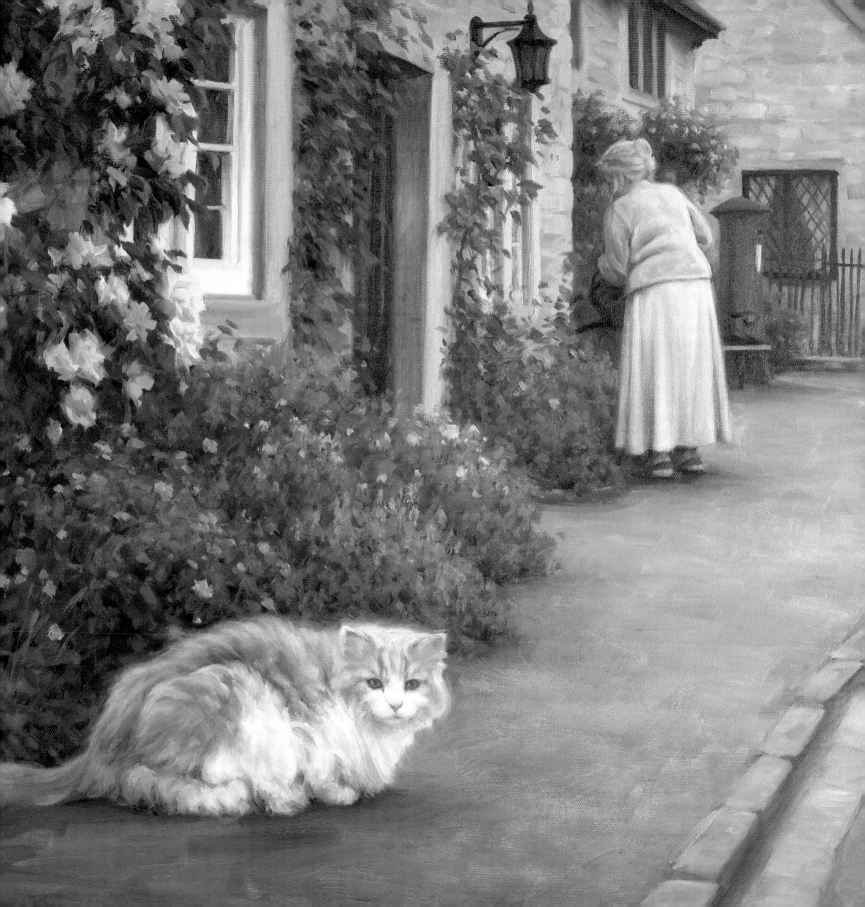

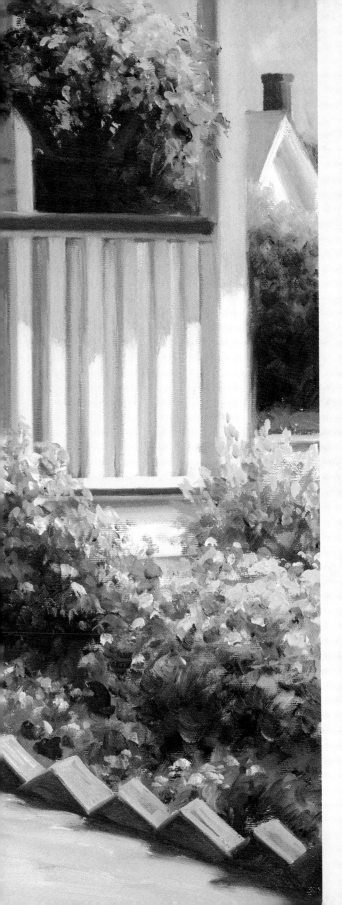

Swept Away

Except a living man there is nothing more wonderful than a book, a message to us from the dead, . . . from human souls we never saw, who lived perhaps thousands of miles away. And yet these, in those little sheets of paper, speak to us, terrify us, teach us, comfort us, open their hearts to us as brothers.

—CHARLES KINGSLEY

Our Giant

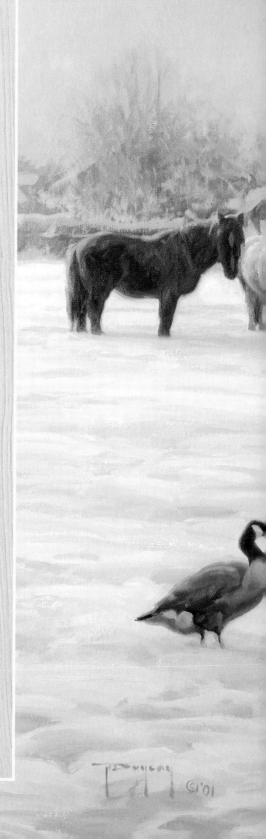

The Judge's house has a splendid porch,

 with pillars and steps of stone,

And the Judge has a lovely flowering hedge

 that came from across the seas;

In the Hales' garage you could put my house and everything I own,

And the Hales have a lawn like an emerald and a row of poplar trees.

Now I have only a little house, and only a little lot,

And only a few square yards of lawn, with dandelions starred;

But when Winter comes, I have something there

that the Judge and the Hales have not,

And it's better worth having than all their wealth—

It's a snowman in the yard.

—JOYCE KILMER

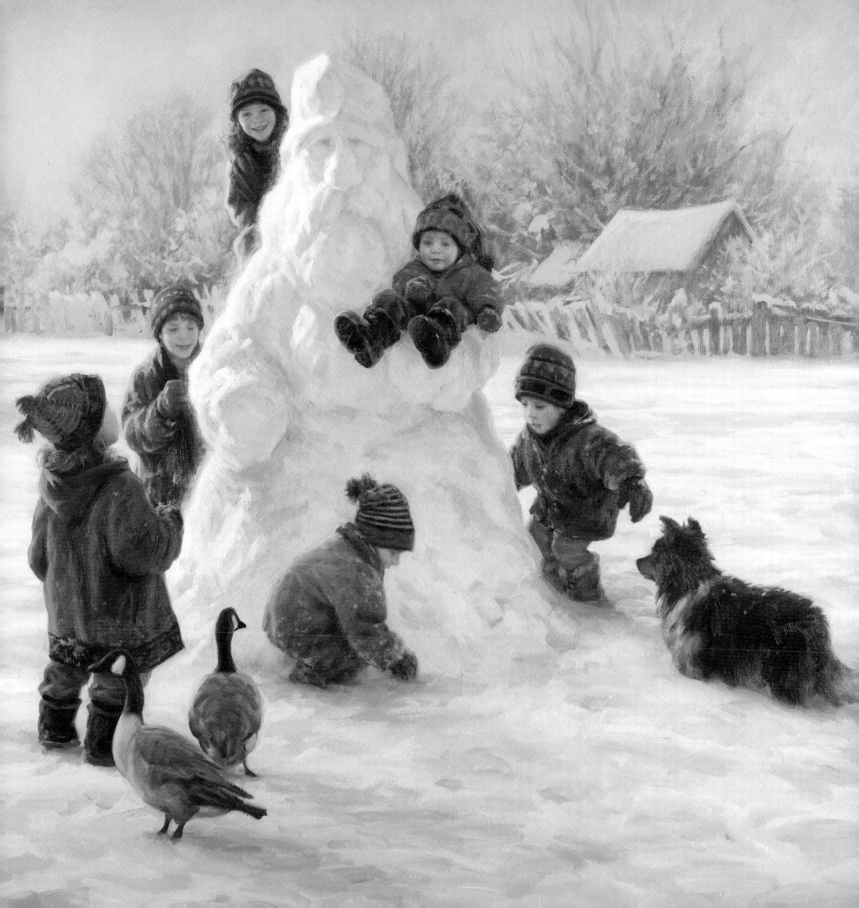

Maggie and Her Mother

Long ago when twilight gathered,

I would turn my wayward feet

Toward my home, with fear and trembling

At the shadows I would meet.

Then I'd scurry through the meadow,

Falter 'neath low-hanging trees,

Stalked by elves of childish fancy;

'Til upon the evening breeze

Came the sounds of sweetest music

That my soul has ever known—

'Twas the voice of Mother singing

Just to lead me safely home.

—ELLA S. BREWER

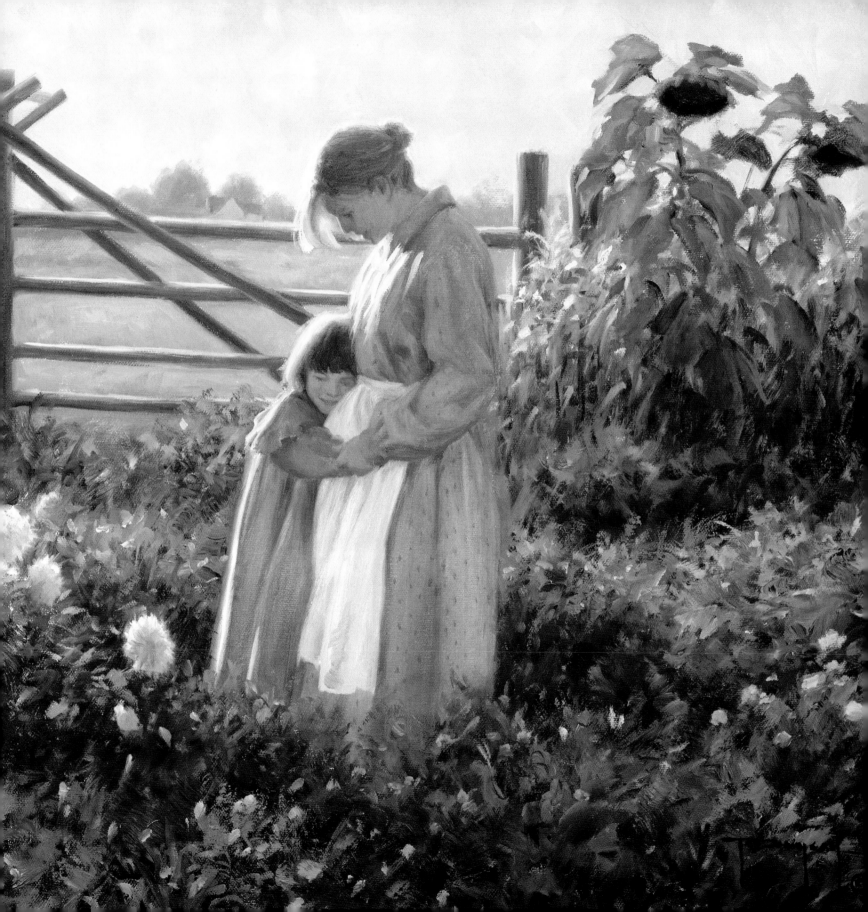

Nothing like Jonathans

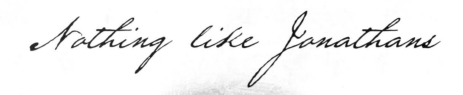

Love doesn't grow on trees like the apples of Eden—it's something you have to make. And you must use your imagination.

—Joyce Cary

That it will never come again is what makes life so sweet.

— Emily Dickinson

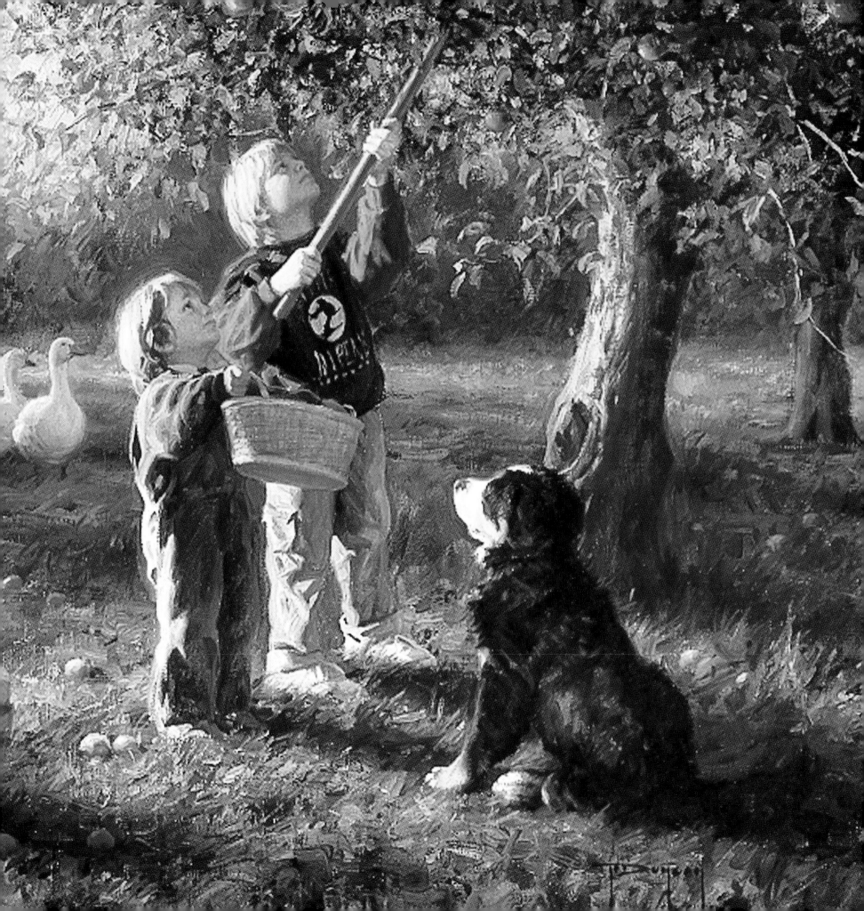

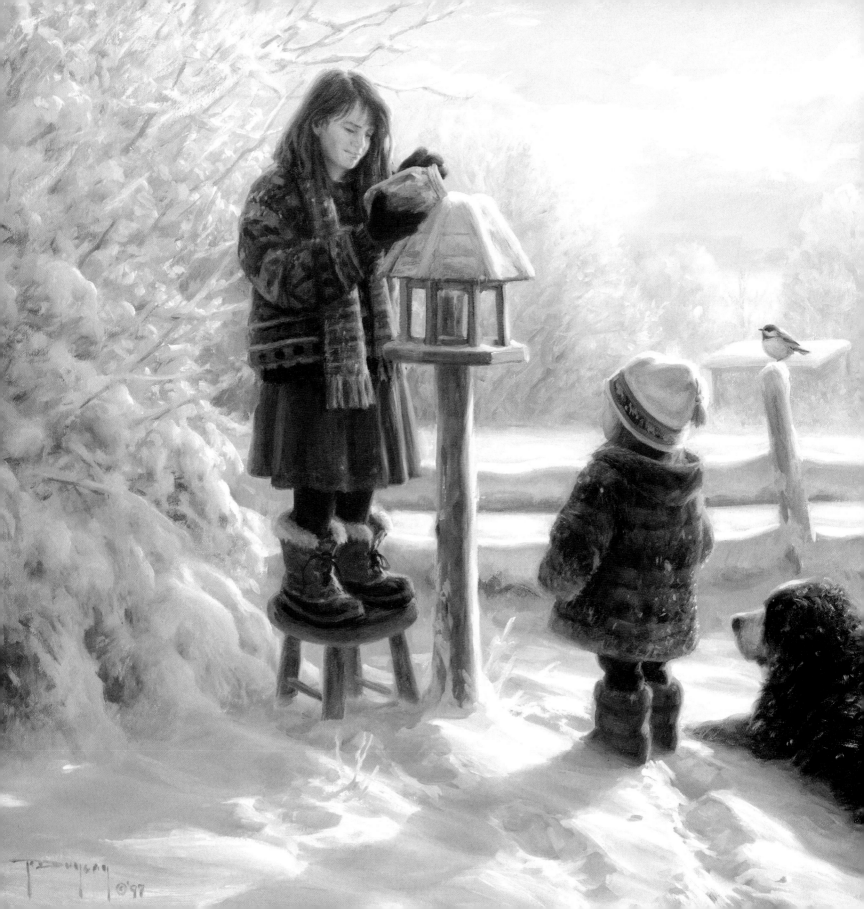

For the Chickadees

To give without any reward, or any notice, has a special quality of its own. . . . There is something of worship or prayer in laying down an offering at someone's feet and then going away quickly. The nicest gifts are those left, nameless and quiet, unburdened with love, or vanity, or the desire for attention.

—ANNE MORROW LINDBERGH

A New Life

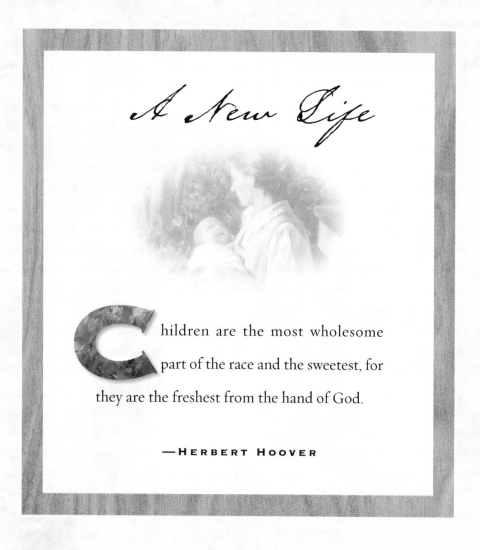

Children are the most wholesome part of the race and the sweetest, for they are the freshest from the hand of God.

—HERBERT HOOVER

Babies are such a nice way to start people.

—Wilhelm Busch

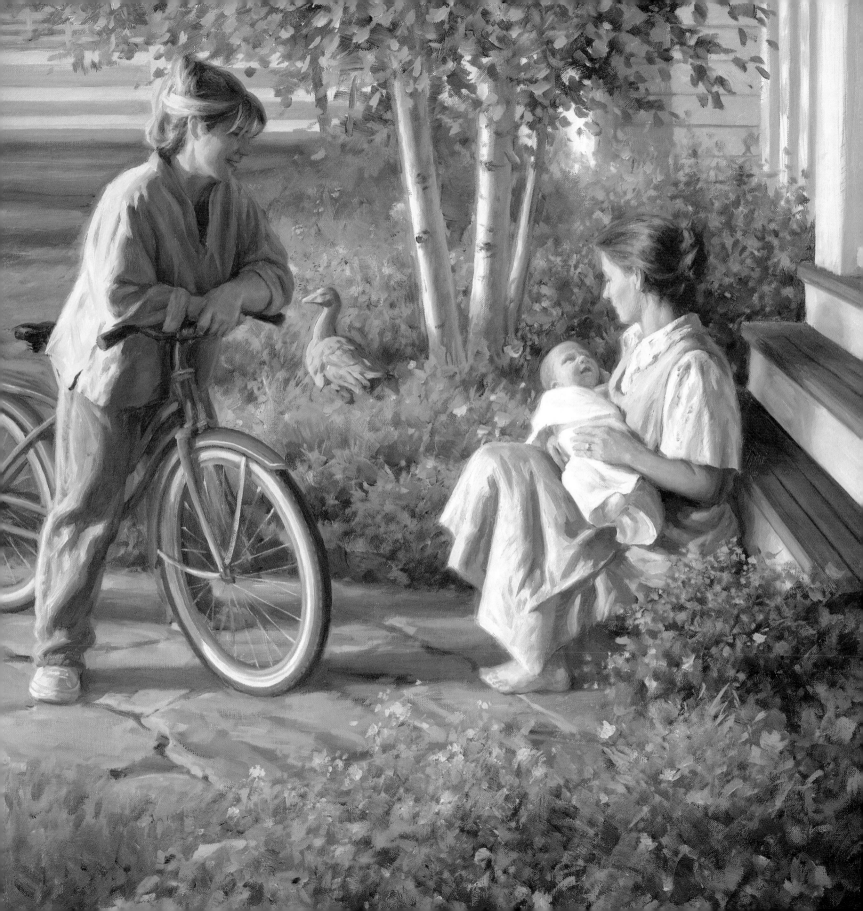

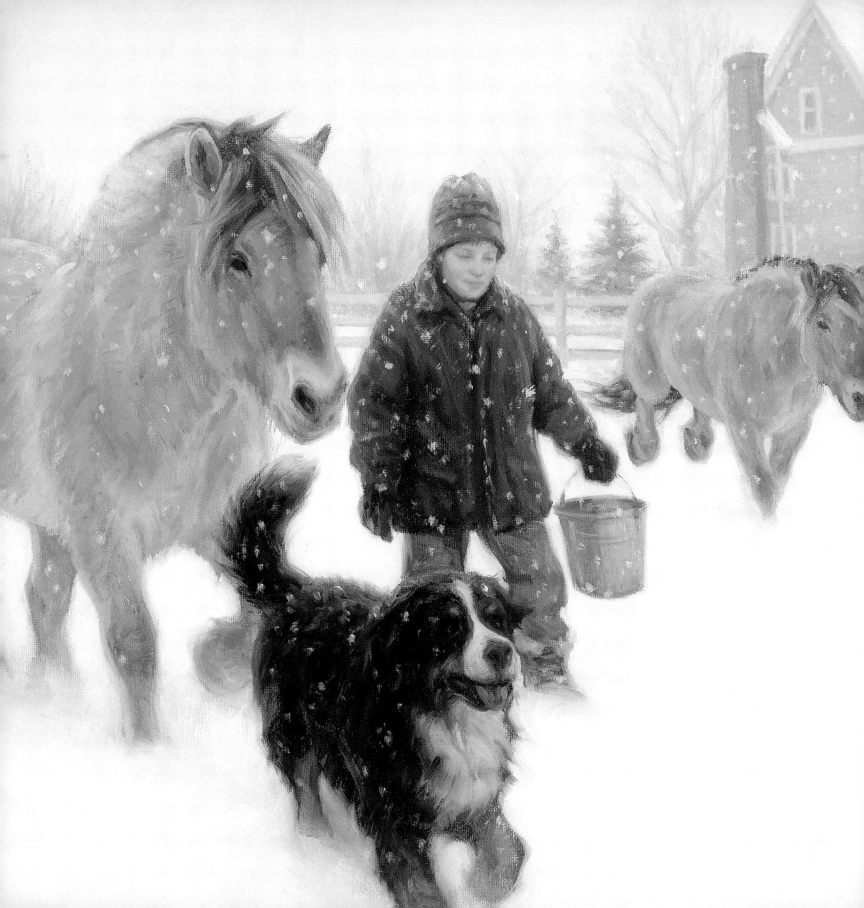

Dinner Call

T he return from your work must be the satisfaction which that work brings you and the world's need of that work. With this, life is heaven, or as near heaven as you can get.

—WILLIAM EDWARD BURGHARDT DU BOIS

We make a living by what we get;
we make a life by what we give.

—Arthur Ashe

Row by Row

Mother taught me to love God's great out-of-doors—the wonder of the seasons, the miracle of a seed, the song of a brook, the return of a bird. Morning after summer morning we worked together in the garden. Her neat rows of vegetables, bordered by sweet peas and delphinium were admired by friends and neighbors near and far. And how often in the opal twilight we climbed our hill to watch night come softly over the valley. . . .

These are some of the gifts my mother gave to me. Time cannot efface them nor thieves break in and take them from me. These gifts are far more precious than rubies, and for them I shall be eternally grateful to the wonderful woman who was my mother.

—SYLVIA PROBST YOUNG

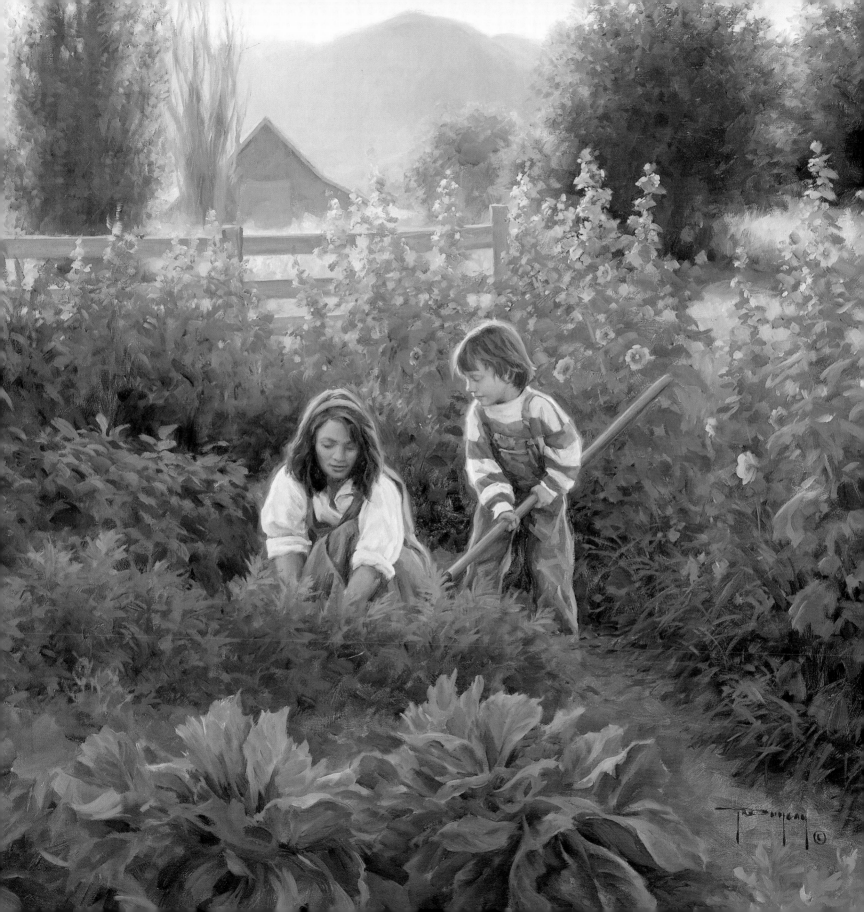

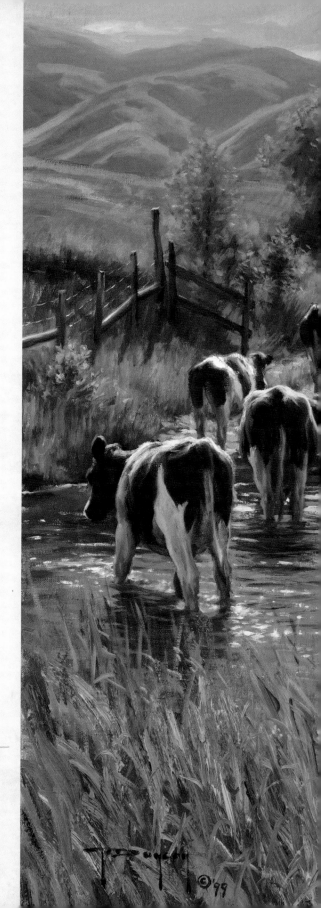

Farms Are for Kids

There they were out in the fields with their kids, the happiest, most solid families you can imagine.

—JOHN FRASER HART

Children have neither a past nor future; they rejoice in the present.

—La Bruyère

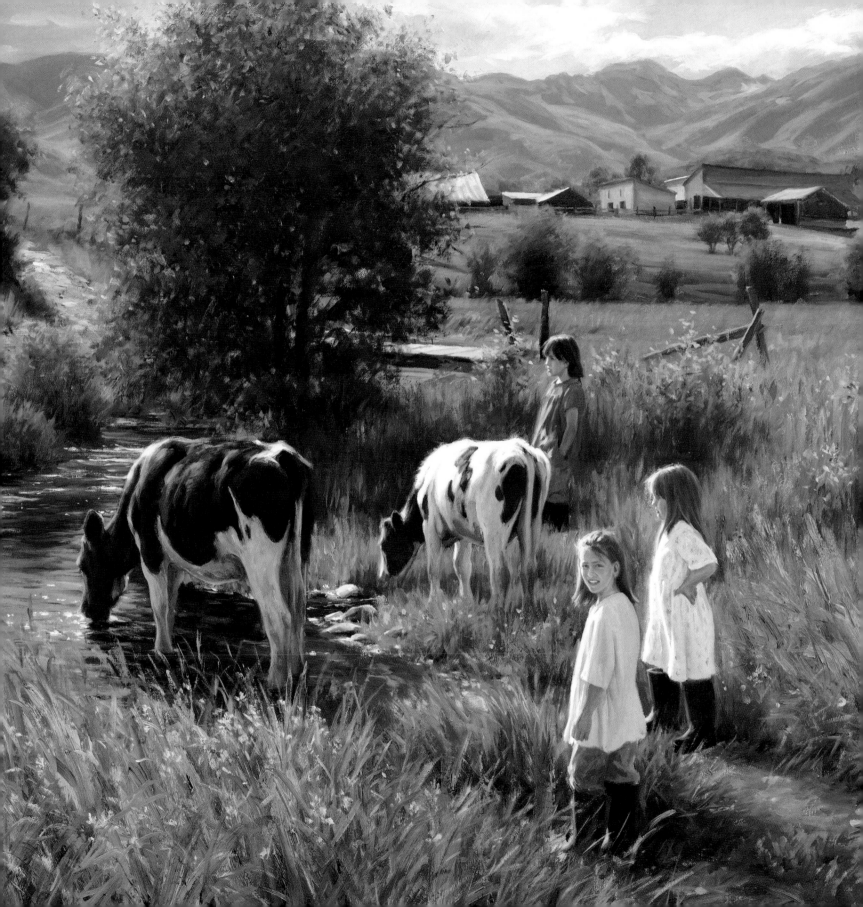

Cold Hands

No man is so poor as to have nothing worth giving: as well might the mountain streamlets say they have nothing to give the sea because they are not rivers. Give what you have. To someone it may be better than you dare to think.

—HENRY WADSWORTH LONGFELLOW

No act of kindness, no matter how small, is ever wasted.

—Aesop

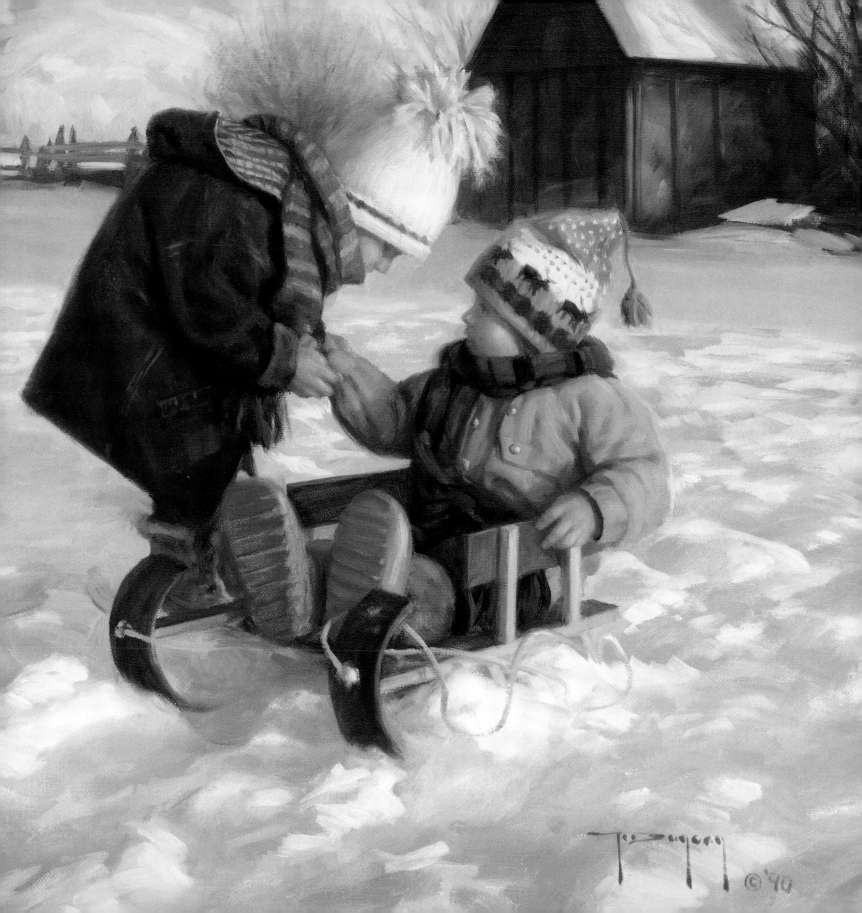

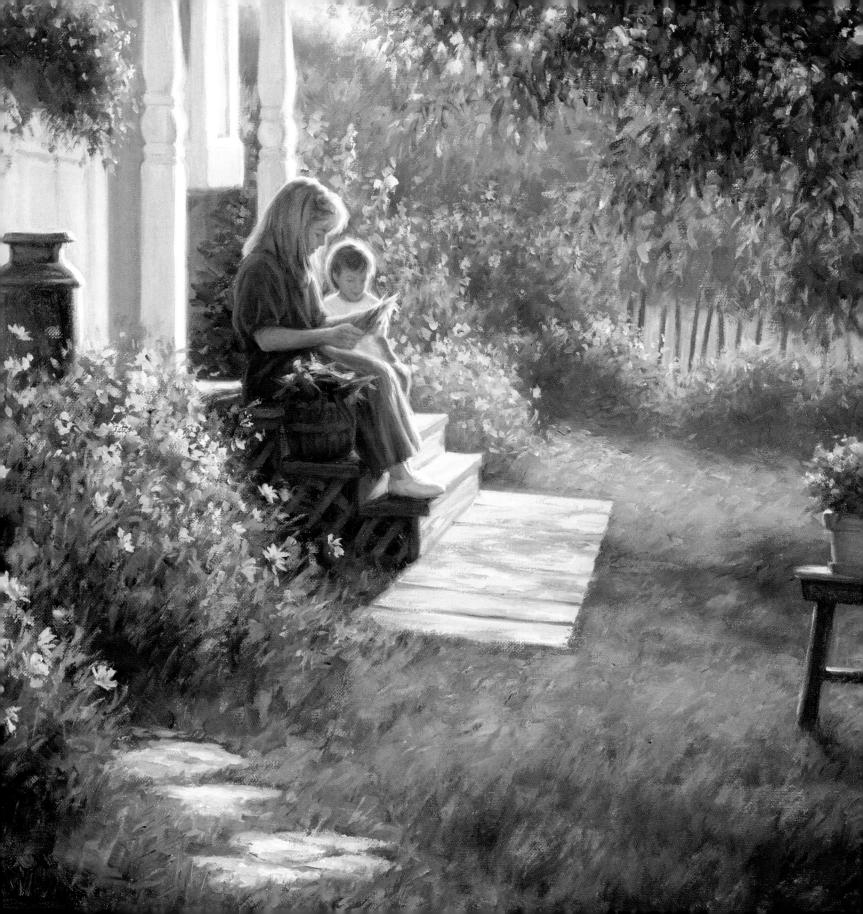

Good Memories

Whoever you are, there is some younger person who thinks you are perfect. There is some work that will never be done if you don't do it. There is someone who would miss you if you were gone. There is a place that you alone can fill.

—JACOB M. BRAUDE

Mother and Son

Dreaming is for Mothers—

Especially the day a newborn finds its way

From God into the world, and to her arms.

What will he be—eventually—this small bit

Of humanity, so like his dad in miniature—

A wisp of soft dark hair above his tiny face?

God colored him adorable, and that he was—

Alert and tender wise—not only as a babe

But through the years of childhood, youth,

And now a man with peaceful, loving heart.

I dreamed of many things when he was born.

And of them all the best came true.

—SYBIL W. LUKE

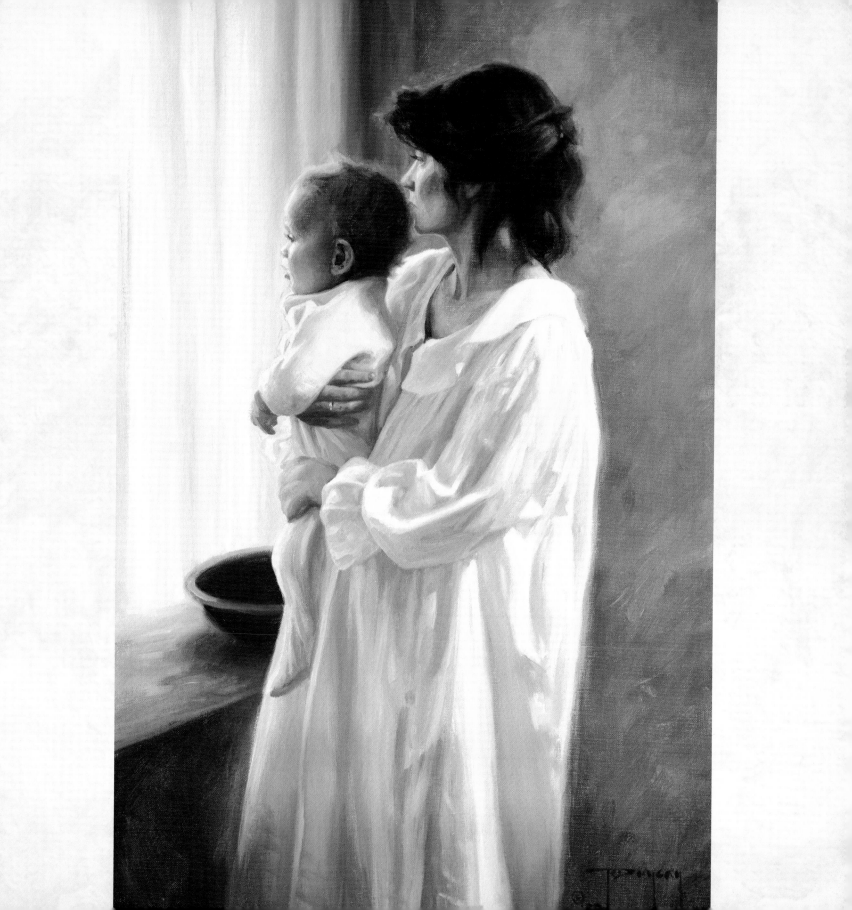

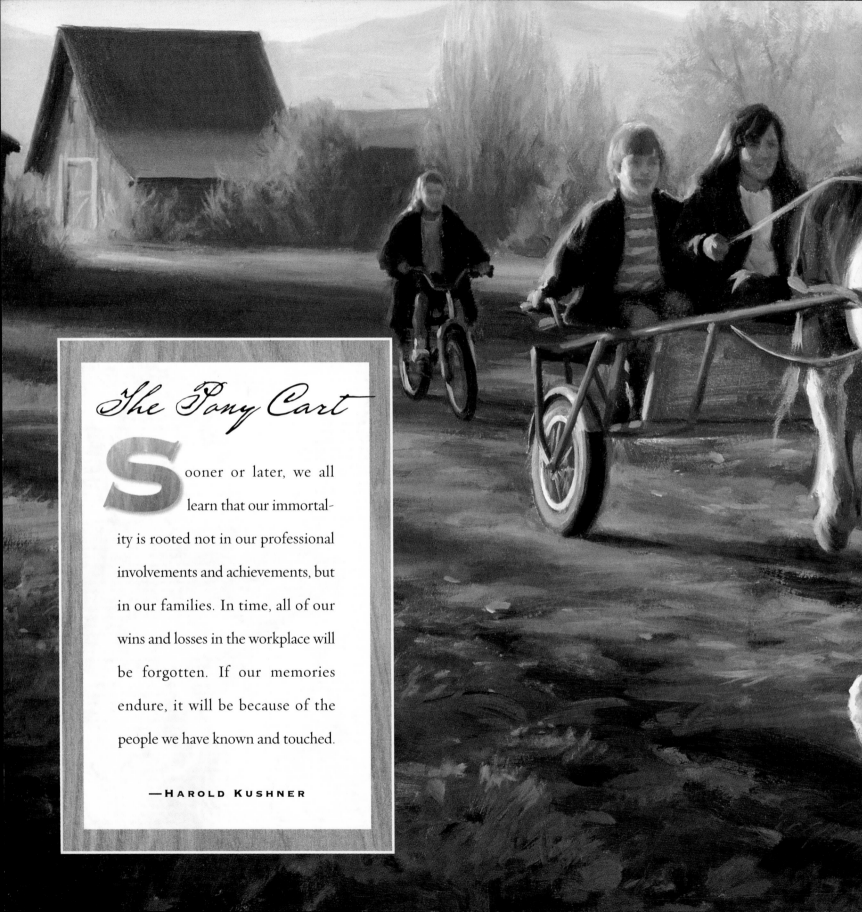

The Pony Cart

Sooner or later, we all learn that our immortality is rooted not in our professional involvements and achievements, but in our families. In time, all of our wins and losses in the workplace will be forgotten. If our memories endure, it will be because of the people we have known and touched.

—HAROLD KUSHNER

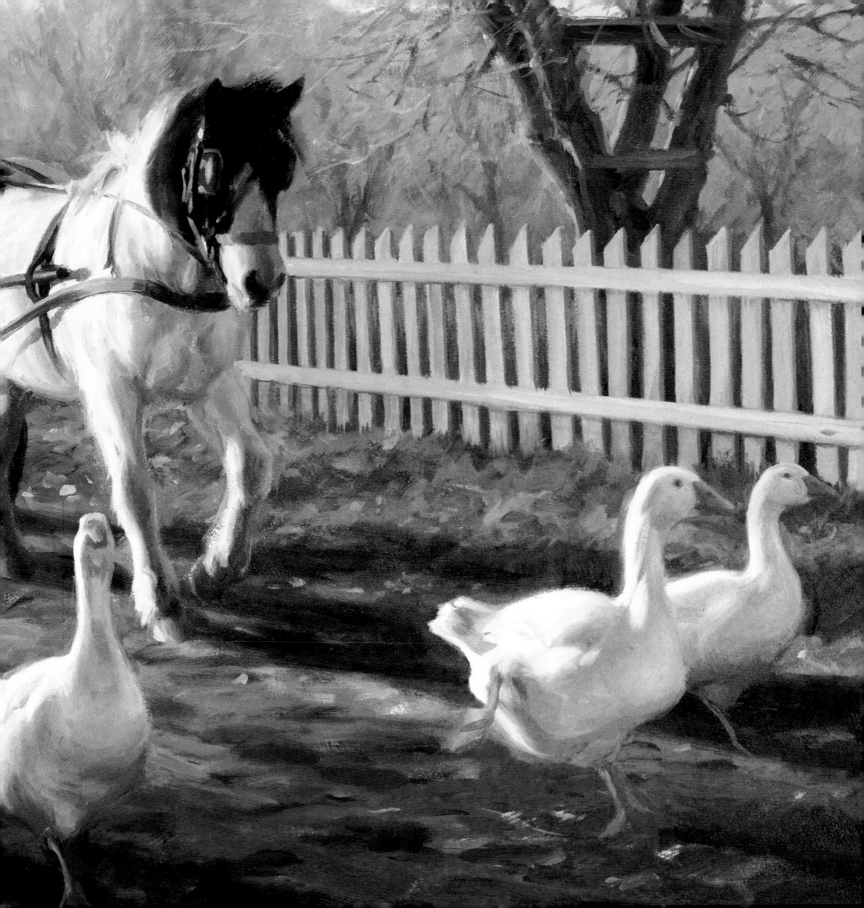

Piggyback

Listen to the MUSTN'TS, child,

Listen to the DON'TS

Listen to the SHOULDN'TS

The IMPOSSIBLES, the WON'TS

Listen to the NEVER HAVES

Then listen close to me—

Anything can happen, child,

ANYTHING can be.

—SHEL SILVERSTEIN

"Pigs are all right,"
he said, "as long as it's
only one or two."
—Mark Teague

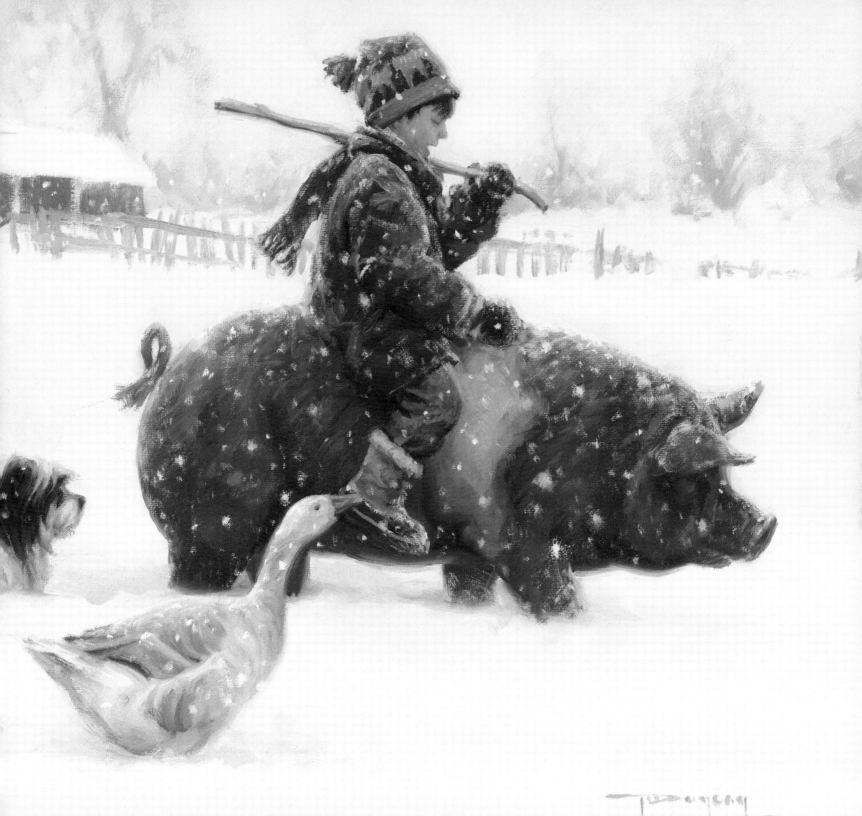

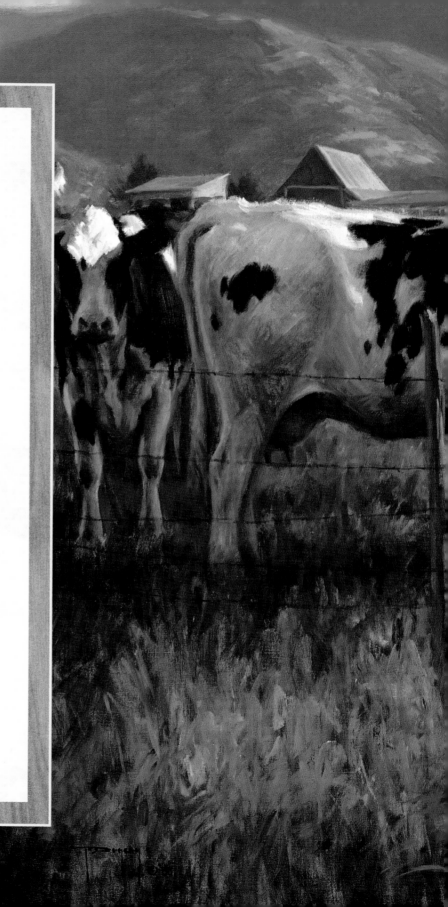

Anniken and the Cows

I f I were in my teens, I would take time to come close to nature. I would learn to fish, to swim, to hike, and to find joy in God's great out-of-doors. I would learn to listen to the earth noises—to hear the birds, the crickets, the sighing of the wind in the trees, the lapping of the water against the shore. I would learn to see the differences in trees, in flowers, in grasses. I would realize again more fully the infinite variety in God's creation. I would learn to feel the difference in the seasons and to love each for what it gives to me. I would know that rain and sunshine are both important in God's plan.

—BERTHA S. REEDER

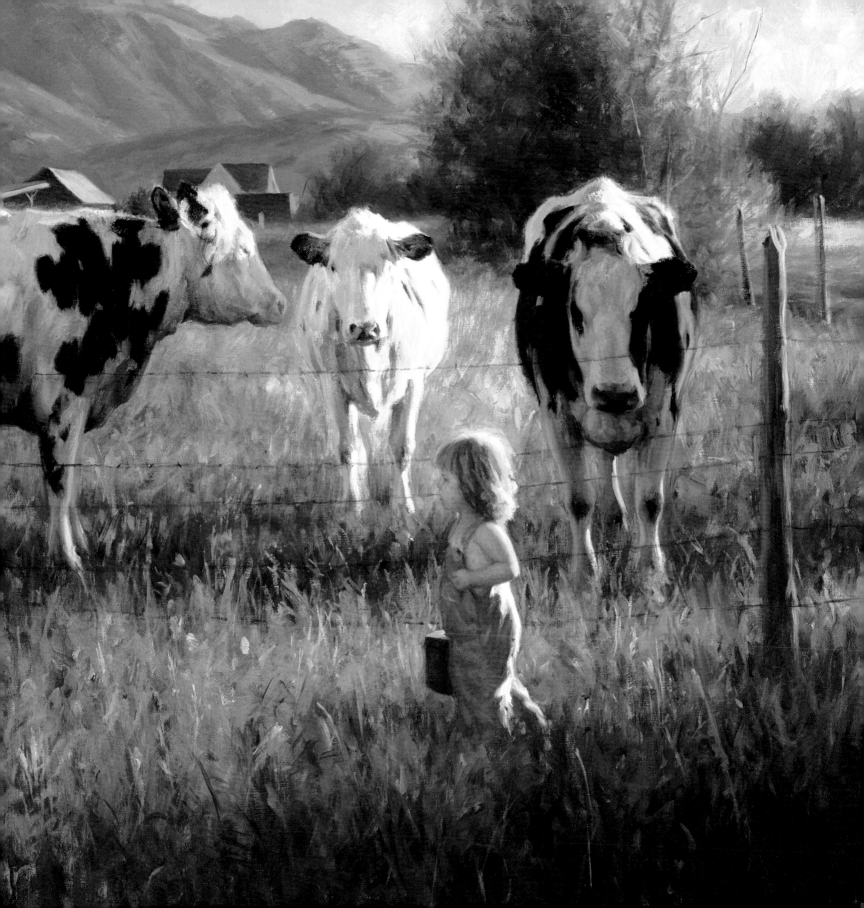

Riding Double

The glory of friendship is not the outstretched hand, nor the kindly smile nor the joy of companship; it is the spiritual inspiration that comes to one when he discovers that someone else believes in him and is willing to trust him.

—RALPH WALDO EMERSON

Shared joy is double joy;
shared sorrow is half sorrow.

—Swedish Proverb

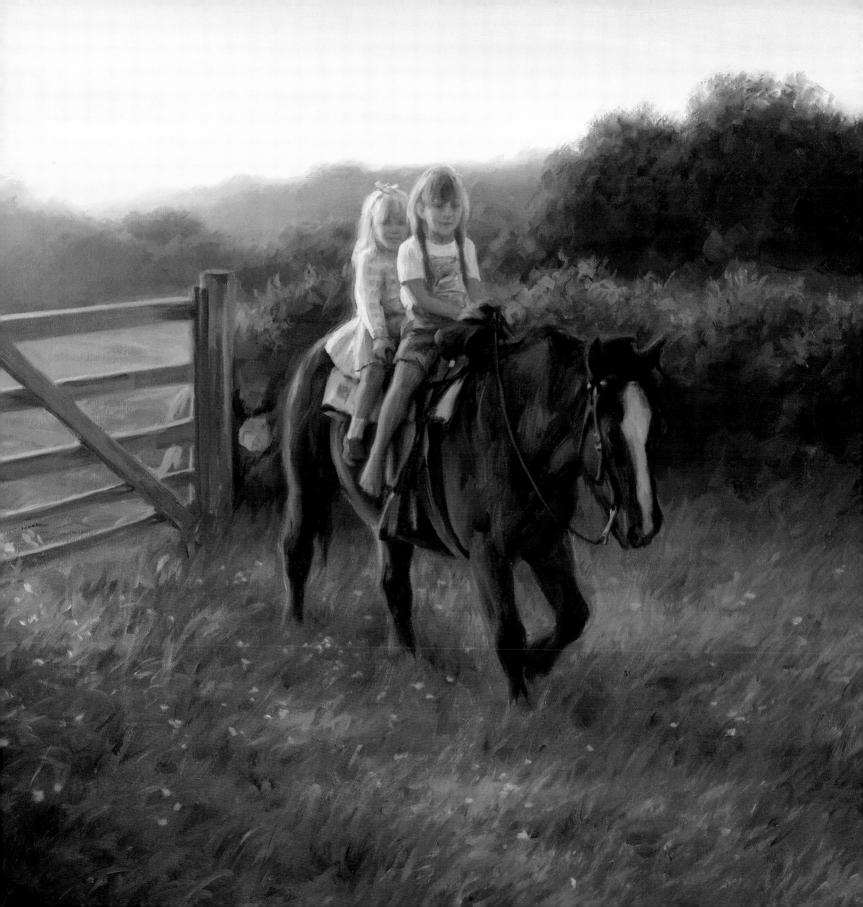

What Brothers Are For

The abundant life begins from within and then moves outward to other individuals. If there is richness and righteousness in us, then we can make a difference in the lives of others, just as key individuals have influenced the lives of each of us for good and made us richer than we otherwise would have been.

—SPENCER W. KIMBALL

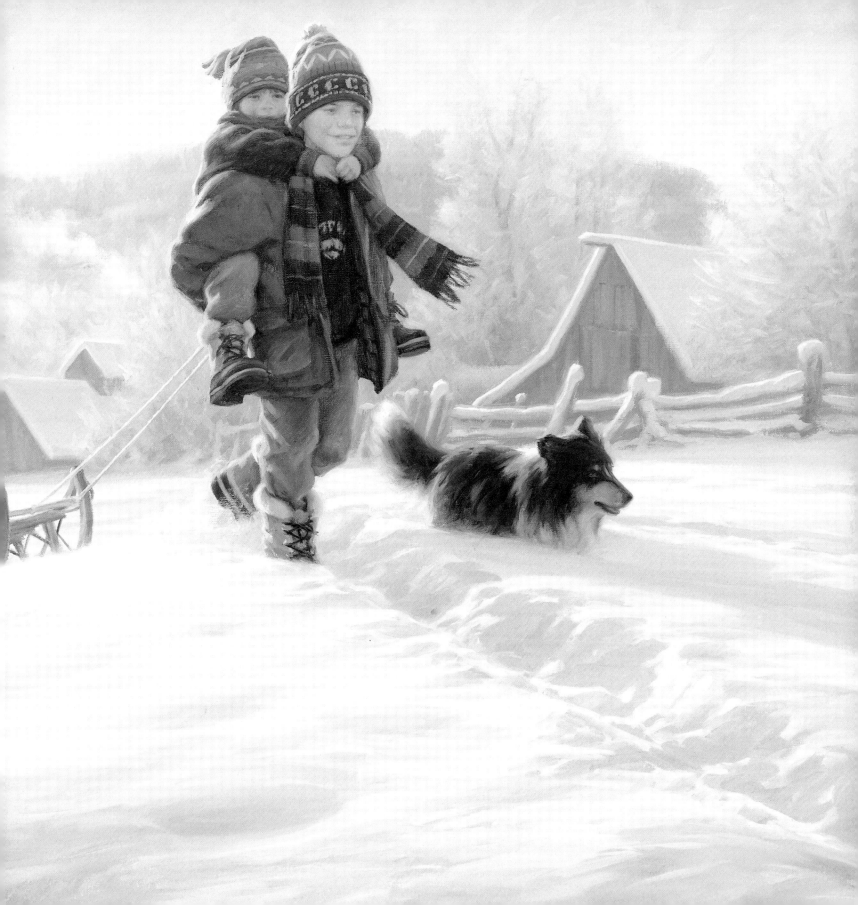

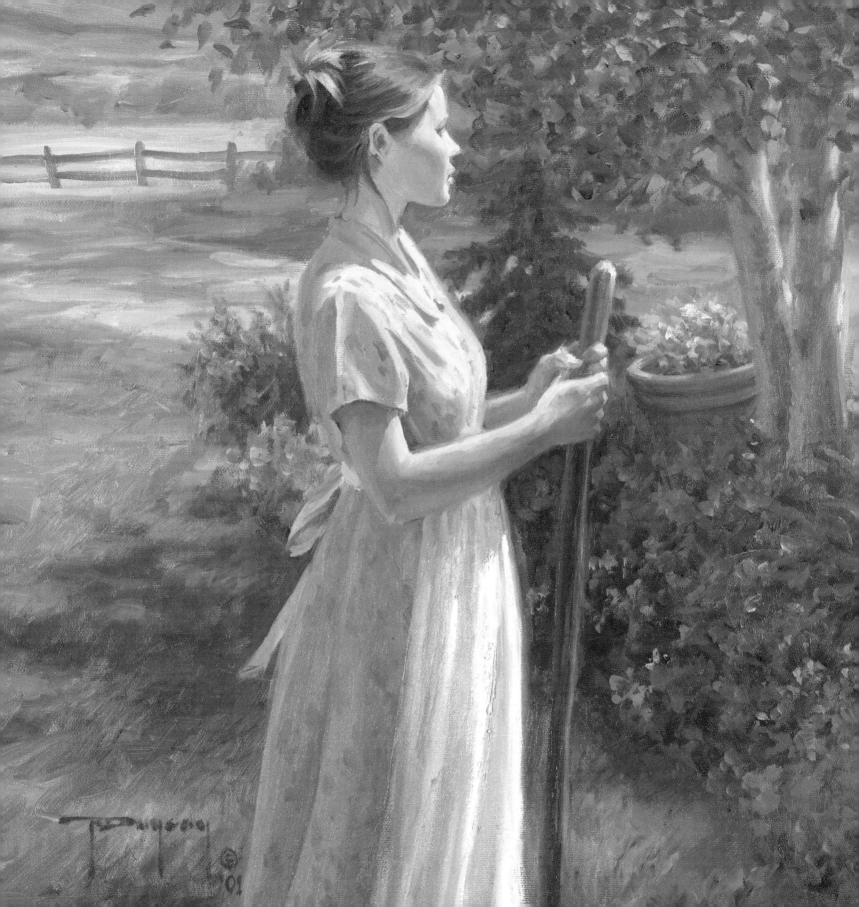

Dreaming

The best remedy for those who are frightened, lonely or unhappy is to go outside, somewhere they can be alone, alone with the sky, nature and God. For then and only then can you feel that everything is as it should be and that God wants people to be happy amid nature's beauty and simplicity.

As long as this exists, and that should be forever, I know that there will be solace for every sorrow, whatever the circumstances. I firmly believe that nature can bring comfort to all who suffer.

—ANNE FRANK

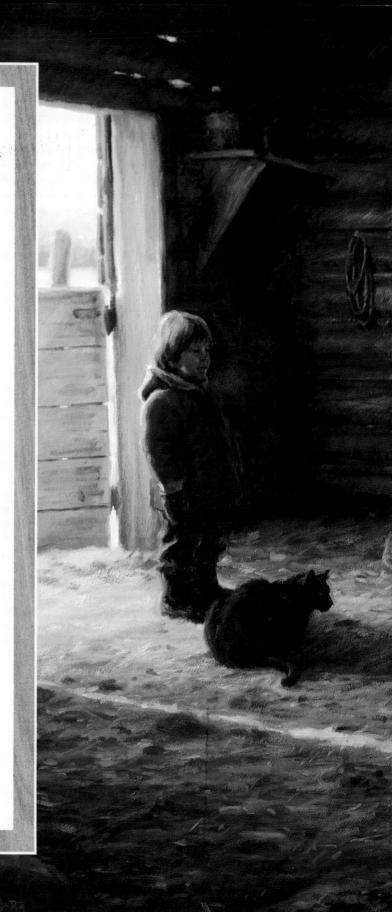

Grandpa's Milk Cows

When I look back upon my early days I am stirred by the thought of the number of people whom I have to thank for what they gave me or for what they were to me. At the same time I am haunted by an oppressive consciousness of the little gratitude I really showed them while I was young. How many of them have said farewell to life without my having made clear to them what it meant to me to receive from them so much kindness or so much care! Many a time have I, with a feeling of shame, said quietly to myself over a grave the words which my mouth ought to have spoken to the departed, while he was still in the flesh

—ALBERT SCHWEITZER

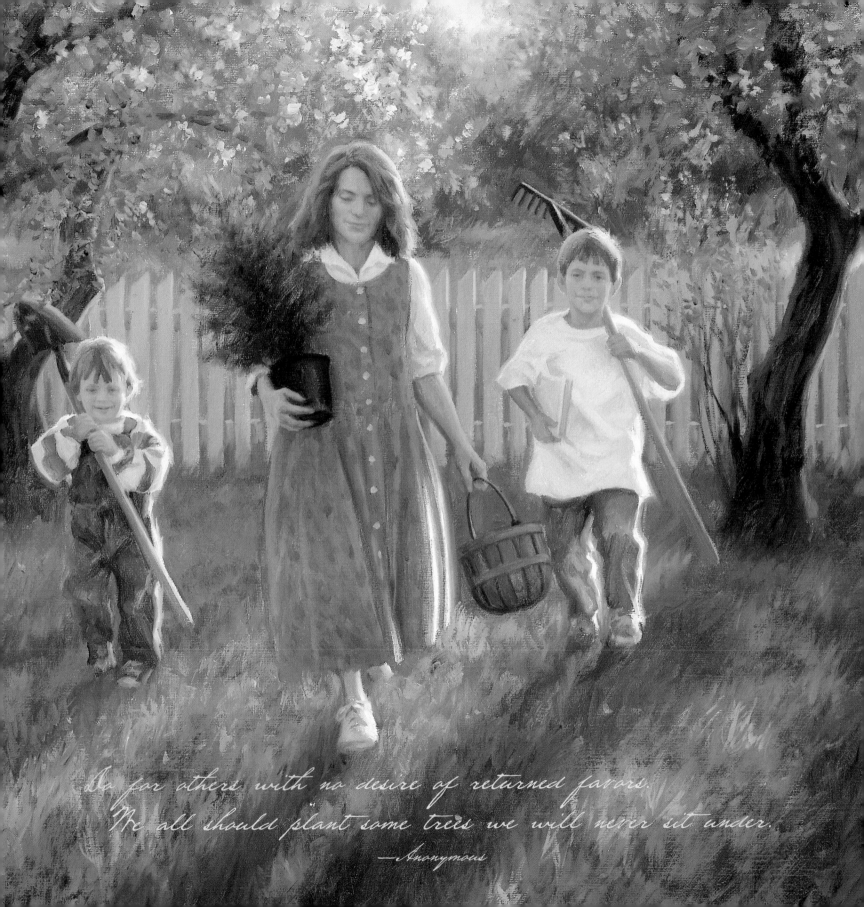

Do for others with no desire of returned favors.
We all should plant some trees we will never sit under.
—Anonymous

Boy's Best Friend

My dog means somebody nice and quiet to be with.

He does not say DO, like my mother.

He does not say DON'T, like my father.

He does not say STOP, like my big brother.

My dog Spot and I just sit quietly together,

And I like him and he likes me.

(And that's why he's my best friend.)

—JOHN C. MAXWELL

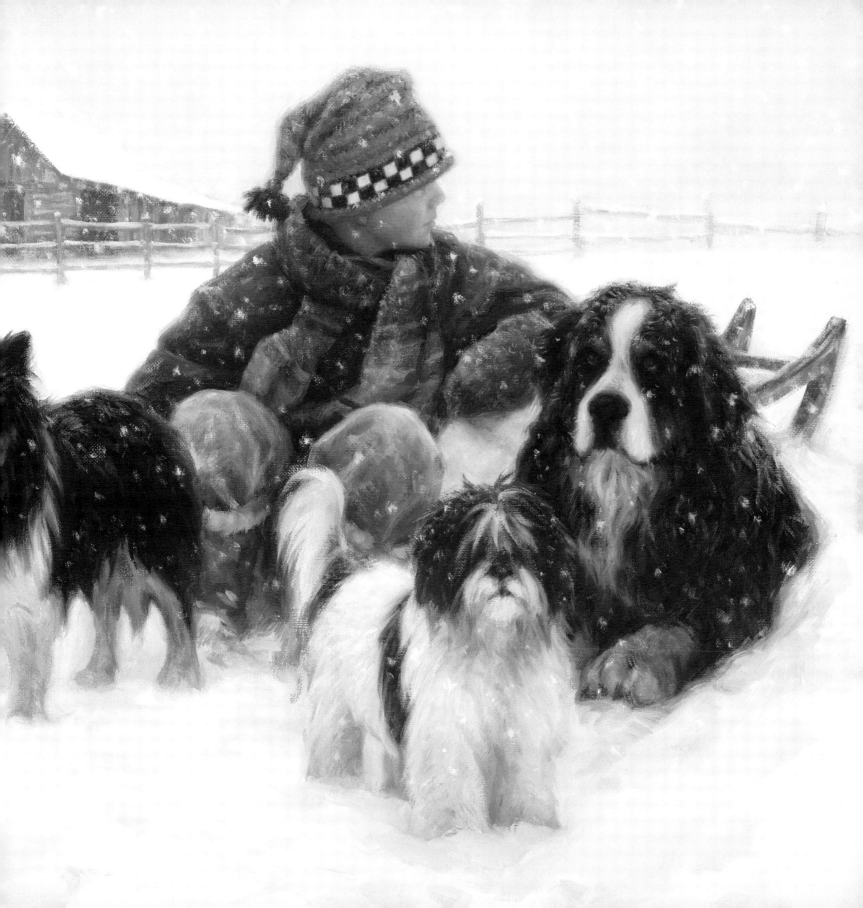

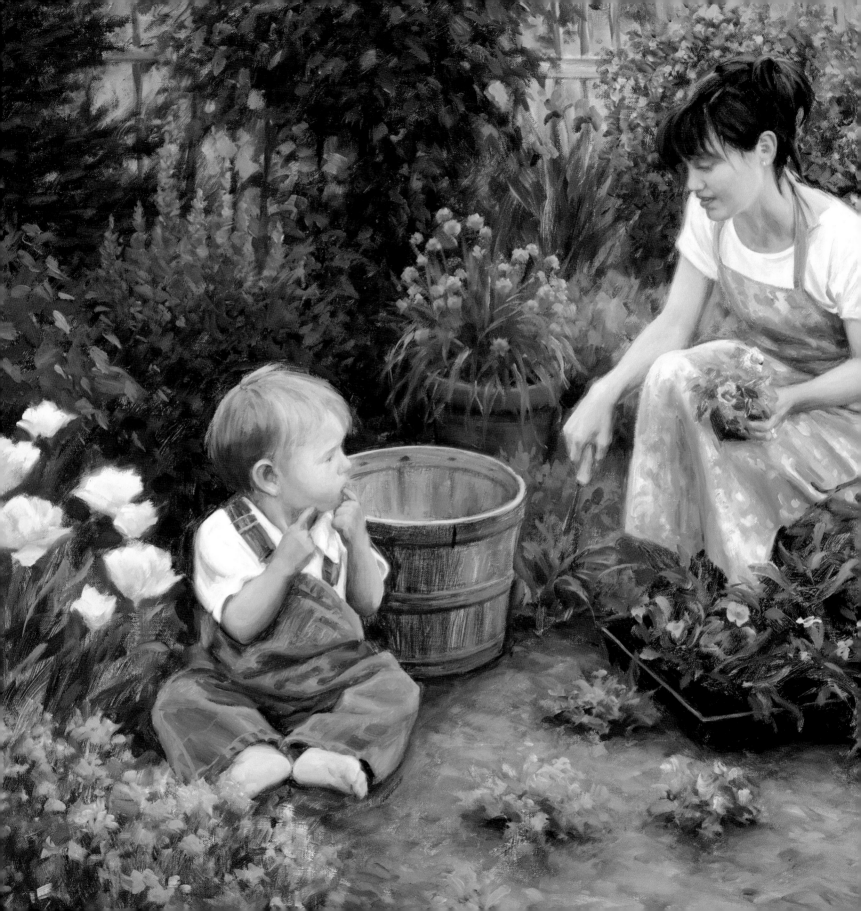

Planting More than Flowers

Children are not lumps of clay that a mother can mold and shape into whatever she thinks would be best. They are seedlings . . . already pears, pines, or petunias. As gardeners, we can add only sunshine, water, fertilizer, time, and love in order to make that growing plant the most beautiful specimen of what it was intended to be.

—LINDA J. EYRE

To Spring Pastures

As I unloaded the last load and looked out across the fertile valley, over the crowns of the cotton-woods and willows along the creek, at the farms we worked on this past month, and at our farm in the distance, I sighed with gratitude for the blessing of living in a neighborhood where sharing labor is a work of love.

—DAVID CLINE

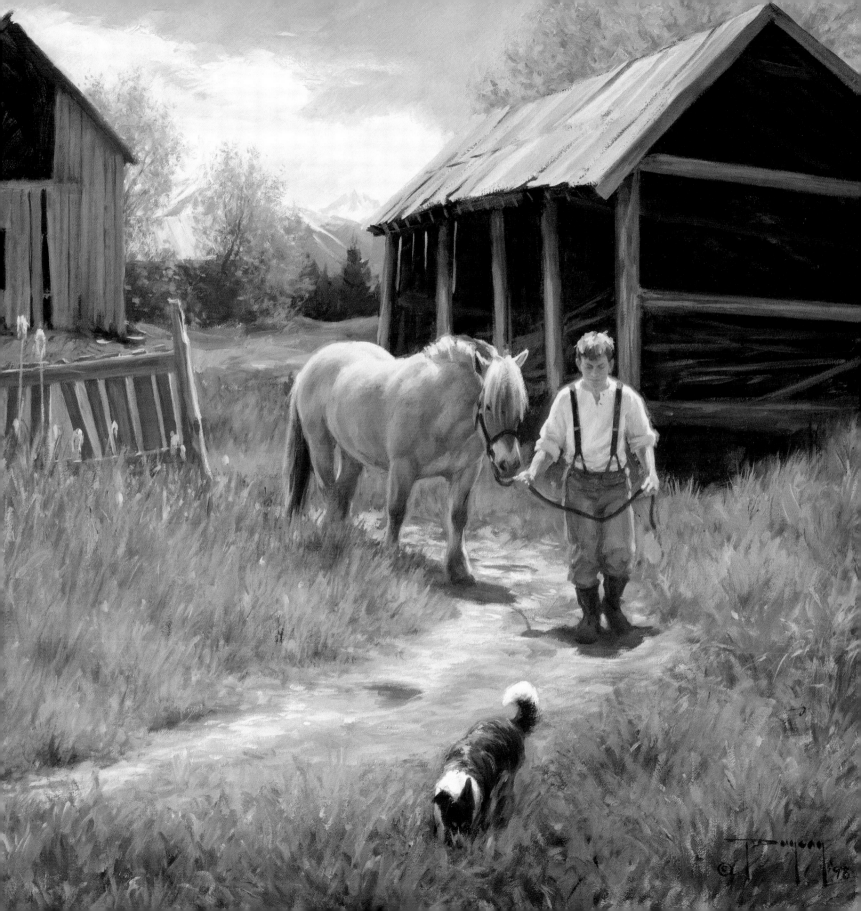

Beautiful Blondes

He prayeth well,

Who loveth well

Both man and bird and beast.

He prayeth best,

Who loveth best

All things both great and small;

For the dear God

Who loveth us,

He made and loveth all.

—SAMUEL TAYLOR COLERIDGE

The pure relationship, how beautiful it is!

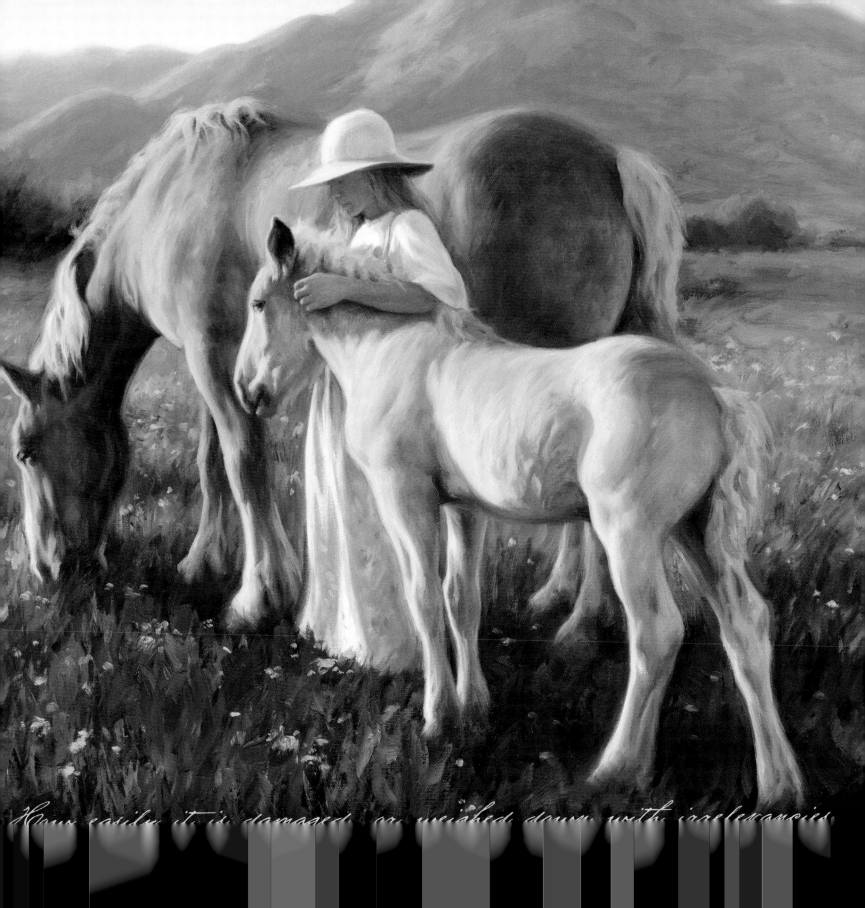

How easily it is damaged or weighed down with irrelevancies.

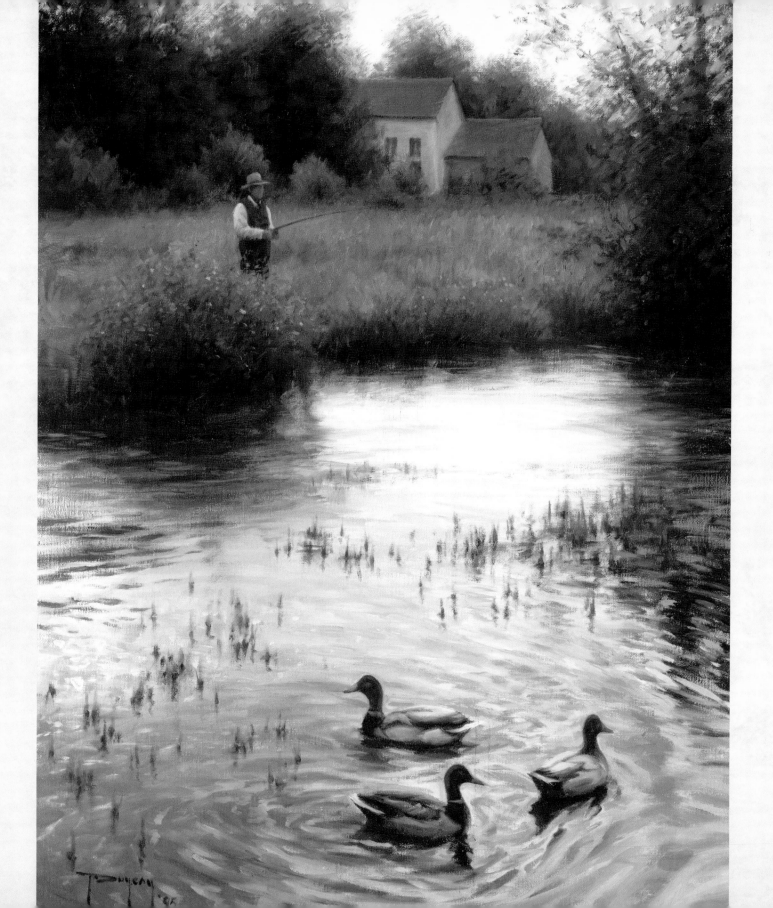

Peaceful Evening

The saddest noise, the sweetest noise,

The maddest noise that grows,—

The birds, they make it in the spring,

At night's delicious close.

—EMILY DICKINSON

Sources

Allington, William. In *Bartlett's Familiar Quotations*. Edited by Justin Kaplan. Boston: Little, Brown, 1992, 504.

Ashe, Arthur. In Michael Lynberg, *Make Each Day Your Masterpiece*. Kansas City: Andrews McMeel Publishing, 2001, 110.

Barthel, Mildred. "Happiness Along the Way." *Ensign*, April 1987, 43.

Beecher, Henry Ward. In Sandra Kuck, *God's Little Wonders*. Eugene, Ore.: Harvest House Publishers, 2002, 19.

Braude, Jacob M. *Braude's Source Book for Speakers and Writers*. Englewood Cliffs, N.J.: Prentice Hall, 1968, 5.

Brewer, Ella S. "Mother's Evening Song." *Ensign,* March 1998, 63.

Burghardt Du Bois, William Edward. In *Bartlett's Familiar Quotations*. Edited by Justin Kaplan. Boston: Little, Brown, 1992, 605.

Cary, Joyce. In Thomas Kinkade and Anne Christian Buchanan, *Simple Little Treasures*. Eugene, Ore.: Harvest House Publishers, 2002, 7.

Casals, Pablo. In *Reader's Digest Quotable*. Pleasantville, N.Y.: Reader's Digest Association, 1997, 202.

Claudius, Matthias. "The Peasant's Song." In *A Garland of Songs*. Translated by Jane Montgomery Campbell. N.p.: Charles S. Bere, 1862.

Cline, David. "The Value of Love." In *The Plain Reader—Essays on Making a Simple Life*. Edited by Scott Savage. New York: Ballantine, 1998, 100.

Coloridge, Samuel Taylor. "He Prayeth Well, Who Loveth Well." In Steve and Becky Miller, *A Child's Garden of Prayer*. Eugene, Ore.: Harvest House Publishers, 1999, [61].

Dickinson, Emily ("Peaceful Evening"). In *The Complete Poems of Emily Dickinson*. Edited by Thomas S. Johnson. Boston: Little, Brown, 1960, 713.

——— ("Nothing Like Jonathans"). In Michael Lynberg, *Make Each Day Your Masterpiece*. Kansas City: Andrews McMeel Publishing, 2001, 105.

Emerson, Ralph Waldo ("An April Storm"). "The Snowstorm." In *One Hundred and One Famous Poems*. Compiled by Roy J. Cook. Chicago: Contemporary Books, 1958, 21.

——— ("Our Friend Murphy"). In Ferenc Mate, *A Reasonable Life*. New York: Albatross, 1993, 141.

——— ("Riding Double"). In *Draper's Book of Quotations for the Christian World*. Edited by Edythe Draper. Wheaton, Ill.: Tyndale House, 1992, 228.

Eyre, Linda J. *The Little Book of Big Ideas about Mothers*. Salt Lake City: Eagle Gate, 2001, 45.

Frank, Anne. *The Diary of a Young Girl: The Definitive Edition*. Edited by Otto H. Frank and Mirjam Pressler. Translated by Susan Massotty. New York: Doubleday, 1991, 195–96.

Gibran, Kahlil. *The Wisdom of Gibran*. Edited by Joseph Sheban. New York: Philosophical Library, 1966, 88.

Grandma Moses. In Michael Lynberg, *Make Each Day Your Masterpiece*. Kansas City: Andrews McMeel Publishing, 2001, 47.

Hart, John Fraser. In Ferenc Mate, *A Reasonable Life*. New York: Albatross, 1993, 131.

Hoover, Herbert. In Helen Steiner Rice and Virginia J. Ruehlmann, *Mother, I Love You*. New York: Gramercy Books, 1999, 34.

Howard, Shirley. "October Morning." Copyright 1981 Shirley Howard. Used by permission.

Irving, Washington. In Helen Steiner Rice and Virginia J. Ruehlmann, *Mother, I Love You*. New York: Gramercy Books, 1999, 77.

Kilmer, Joyce. "The Snowman in the Yard." In *Joyce Kilmer—Poems, Essays and Letters*. Edited by Robert Cortes Holliday. Garden City, N.Y.: Doubleday, Doran and Co., 1943, 122.

Kimball, Spencer W. "The Abundant Life." Reprinted in *Classic Talk Series*. Salt Lake City: Deseret Book, 1998, 31.

Kingsley, Charles. In *Inspirational Classics for Latter-day Saints*. Compiled and edited by Jack M. Lyon. Salt Lake City: Eagle Gate, 2000, v.

Kushner, Harold. "Make More Family Time." *Redbook*, January 1990, 93.

La Bruyere. In Sandra Kuck, *God's Little Wonders*. Eugene, Ore.: Harvest House Publishers, 2002, 42.

Larsson, Carl. *The World of Carl Larsson*. Translated by Alan Lake Rice. La Jolla, Calif.: Green Tiger Press, 1982, 54.

Lindbergh, Anne Morrow ("Beautiful Blondes"). *Gift from the Sea*. New York: Pantheon Books, 1955, 64.

——— ("For the Chickadees"). *The Flower and the Nettle: Diaries and Letters of Anne Morrow Lindbergh*. New York: Hartcourt Brace Jovanovich, 1976, 77–78.

Longfellow, Henry Wadsworth. In *A Pocketful of Joys*. Edited by Patricia Dreier. Norwalk, Conn.: C. R. Gibson, 1985, 77.

Lucado, Max. *Grace for the Moment—Inspirational Thoughts for Each Day of the Year*. Nashville, Tenn.: J. Countryman, 2000, 230.

Luke, Sybil W. "A Mother's Reflection." *Ensign,* April 1987, 31.

Mandino, Og. *The Choice*. New York: Bantam, 1986, 103.

Maxwell, John C. *The Treasure of a Friend*. Nashville, Tenn.: J. Countryman, 1999, 59.

Melville, Herman. In Michael Lynberg, *Make Each Day Your Masterpiece*. Kansas City: Andrews McMeel Publishing, 2001, 86.

Nightingale, Florence. In Michael Lynberg, *Make Each Day Your Masterpiece*. Kansas City: Andrews McMeel Publishing, 2001, 9.

Reeder, Bertha S. "If I Were in My Teens." *Improvement Era*, June 1954, 470.

Schweitzer, Albert. *Memories of Childhood and Youth*. Translated by C. T. Campion. New York: Macmillan, 1950, 65–66.

Silverstein, Shel. "Listen to the MUSTN'TS." In *Where the Sidewalk Ends*. New York: HarperCollins, 1974, 27.

Swedish proverb. In Michael Lynberg, *Make Each Day Your Masterpiece*. Kansas City: Andrews McMeel Publishing, 2001, 55.

Teague, Mark. *Pigsty*. New York: Scholastic, 1994, [9].

Thoreau, Henry David. *Walden and Civil Disobedience*. New York: Penguin Books, 1983, 263–64.

Tolino, Cheryl Ann. "A Piece of Earth in a Vacuum of Time." *Ensign*, September 1983, 21.

Young, Sylvia Probst. "Gifts from My Mother." *Relief Society Magazine*, May 1965, 339–40.